日本 静寂と喧騒

(Nihon shizukade sawagi)

Japan
Tranquility and tumult

Nicolas Wauters

Lannoo

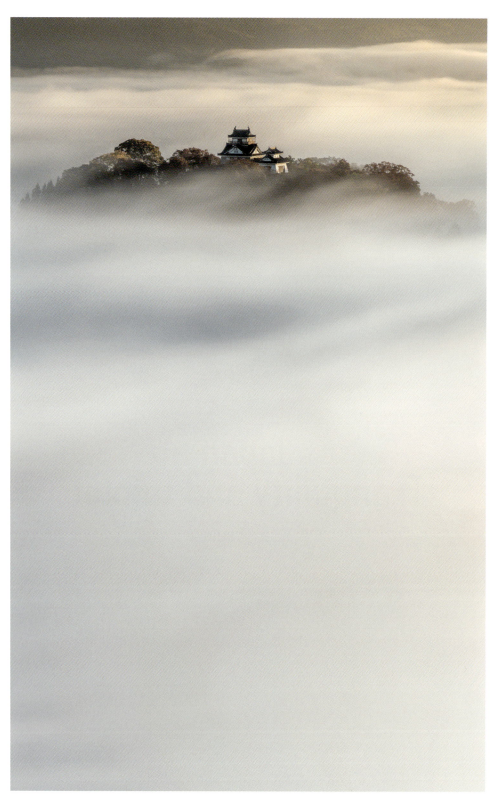

Echizen-Ōno Castle in Ōno

Foreword \| 前書き	5
Mount Fuji \| 富士山	8
Tokyo \| 東京	16
Asakusa \| 浅草	44
Shinjuku \| 新宿	54
Shibuya \| 渋谷	64
Akihabara \| 秋葉原	74
Train \| 電車	82
Kantō \| 関東	92
Kyoto \| 京都	102
Religion \| 宗教	120
Rules \| 規則	128
Osaka \| 大阪	134
Gastronomy \| 食事	144
Yokohama \| 横浜	152
Kobe \| 神戸	158
Earthquakes \| 地震	164
Kōyasan \| 高野山	168
Matsumoto \| 松本	176
Kyūshū \| 九州	184
Hokkaidō \| 北海道	194
Acknowledgements \| あとがき	208

'From a childhood fascination...

Fascinated since my childhood by Japan and in particular by Tokyo, as much for its ultra-modern aspects as for its traditional side, I have been living there since 2013 with my Japanese wife, Midori. Having spent years wandering the streets of the capital, on foot, by train or subway, I discovered this magical and atypical city, its inhabitants, its crazy rhythm, its culture, and its paradoxes. I quickly realized that the immensity of this city makes it difficult to completely understand.

I then decided to create my own company to help tourists discover the city in the best way possible according to their availability and expectations. My greatest satisfaction today is witnessing the wonder of travelers when they walk through the city for the first time.

The growing interest that 5,000 or so travelers have shown for my work as a guide in Tokyo, but also throughout Japan, has allowed me to expand my activity to photography. That's why, since 2019, I combine my activities of guide and photographer to propose photo workshops on the archipelago.

... to a photobook

In this beautiful book of photos, I am happy to share with you my love and perception of Japan, far from the usual stereotypes. I wanted to show Tokyo and its impressive infrastructures, its ancient and modern architectures, all sublimated by an atypical calm and serenity that contrast with the image we have of Japan.

Conceived as a travel diary, it will help you discover the most interesting places of the archipelago and its grandiose natural sceneries, its traditional as well as contemporary culture, themes such as religion, trains, codes, Mount Fuji, the emblem of Japan...

A picture being worth a thousand words, I preferred to stick to short texts.

I wish you a nice discovery of Japan, with the hope to share with you my passion for this fascinating and wonderful country. And, maybe, to meet you there soon!

Nicolas Wauters

Tour website: www.tokyotripweb.com
Photo website: www.nicolaswauters.com
Instagram: www.instagram.com/wauters_nicolas/
Facebook: www.facebook.com/Wautersnicolasphotography
E-mail: info@nicolaswauters.com

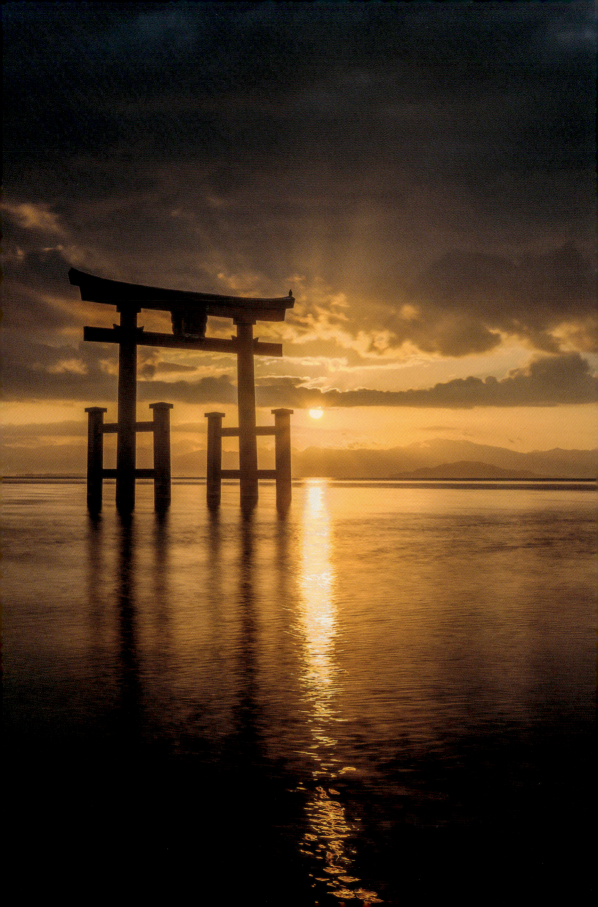

Both a photobook and a guide!

I aimed to improve the experience of visitors by offering them, via their smartphone, an online map with several hundred addresses carefully selected by Tokyo Trip. In a country where 4G (or even 5G) coverage is widespread, you will benefit from an easy and quick access to the various emblematic places I have identified. And this, without even having to take the book with you.

How does it work?

Scan the QR code with your smartphone or tablet via 4G or a portable Wi-Fi device.

An online Google map will then appear, showing your location in real time and all the places to visit nearby. The map will also show you the best route to take and provide you with useful information about transportation.

Designed primarily for you, this online map application has one last advantage: its longevity. Tokyo Trip commits itself to updating constantly in order to, among other things, add the new musts.

Have a good trip!

Floating Torii on the shores of Lake Biwa

(Fuji-san)

Mount Fuji

Who hasn't heard of Mount Fuji? A symbol of Japan as iconic as the national flag, the venerated Fuji-san, as it is called in Japanese, inspires as much as it impresses with its 3,776m height.

As the highest point of the archipelago, Mount Fuji is also visible from many places in Japan.

In Tokyo, climbing up one of the many panoramic skyscrapers is enough to discover Mount Fuji in the early morning, while having breakfast, or at the end of the day under a marvellous sunset, with a cup of tea.

With its perfectly conical shape, the volcano, whose summit is covered by snow for a good part of the year, continues to fascinate – starting with artists who have already dedicated an infinite number of prints, haikus and books to it.

Revered as a deity since ancient times, Fuji-san has been listed as a Unesco World Heritage Site since 2013 as a sacred place and a source of artistic inspiration.

Only recently accessible to women

From July to September, more than 250,000 people climb its slopes and, throughout the year, millions of tourists, mainly Japanese, crowd around the famous mountain.

However, throughout history and due to the prohibitions imposed by the Shinto and Buddhist religions, Mount Fuji was for a long time inaccessible to the profane.

Therefore, it is only very late in the history of Japan that men started to climb this sacred mountain.

For the record, it is also important to note that women were not allowed to climb the volcano until 1830, and even then, in successive stages. Indeed, in the Japanese religion, women were excluded from sacred places for a long time.

A wise man or... a fool

A Japanese proverb says that the one who climbs Fuji-san once is a wise man and the one who climbs it twice is a fool... For your information, the author of this book has already climbed Mount Fuji seven times and regularly organises five different types of trails.

If you go to Japan and don't have the opportunity to see or climb the mountain, you should at least keep as a souvenir a ¥1,000 bill with the famous Mount Fuji on it.

Mount Fuji's reflection on Lake Tanuki in Fujinomiya

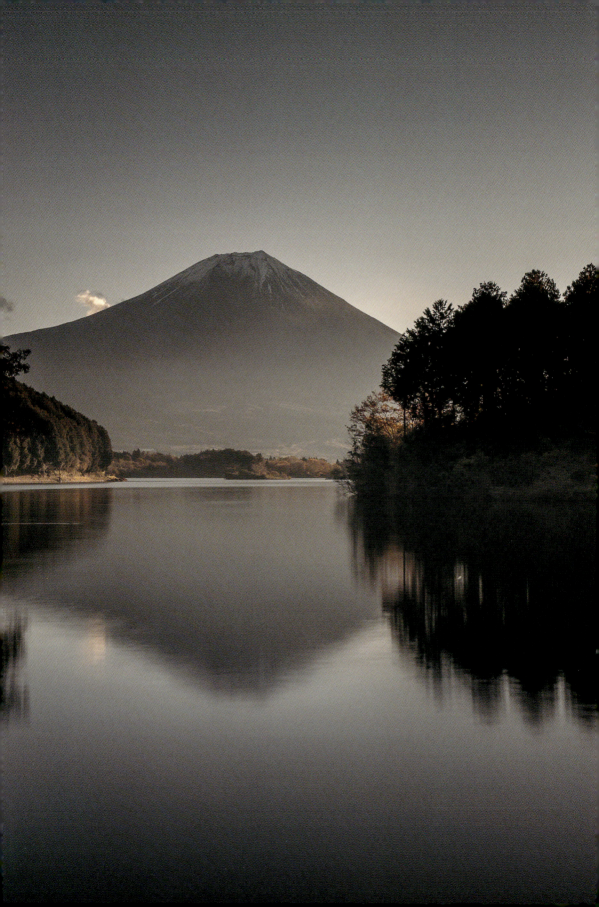

Mount Fuji

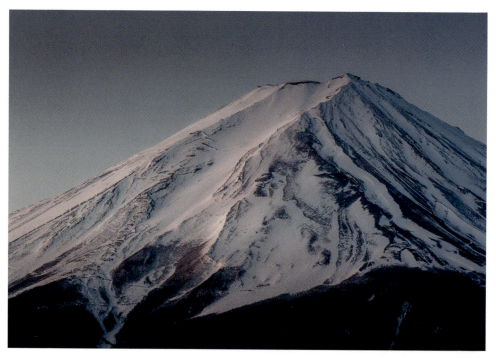

Permanent snow on Mount Fuji

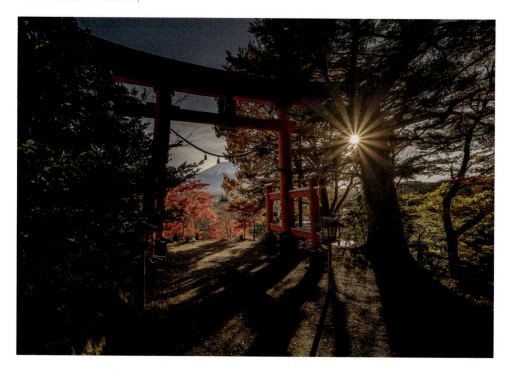

Mount Fuji from the entrance of Arakurayama Sengen Park

The local Fujikyuko Line connecting the stations of Ōtsuki and Kawaguchiko ▶

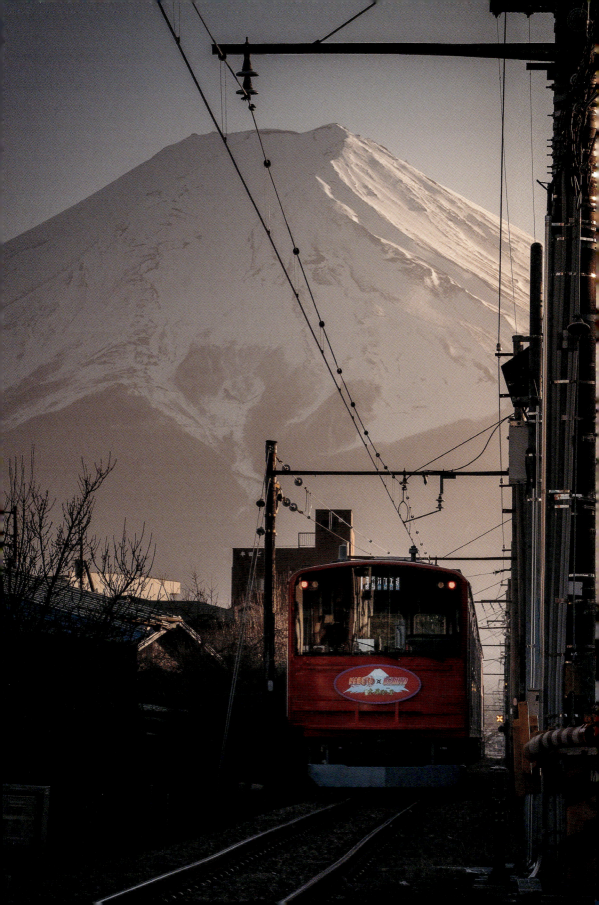

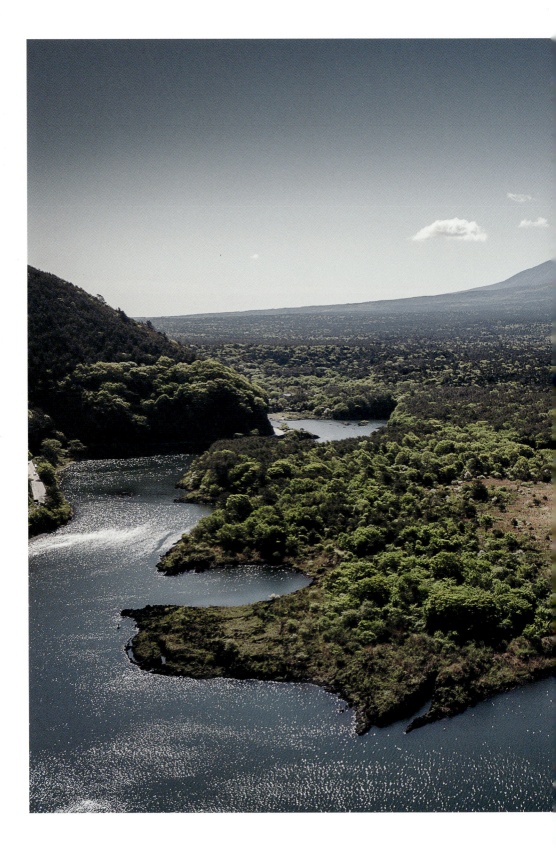

Mount Fuji

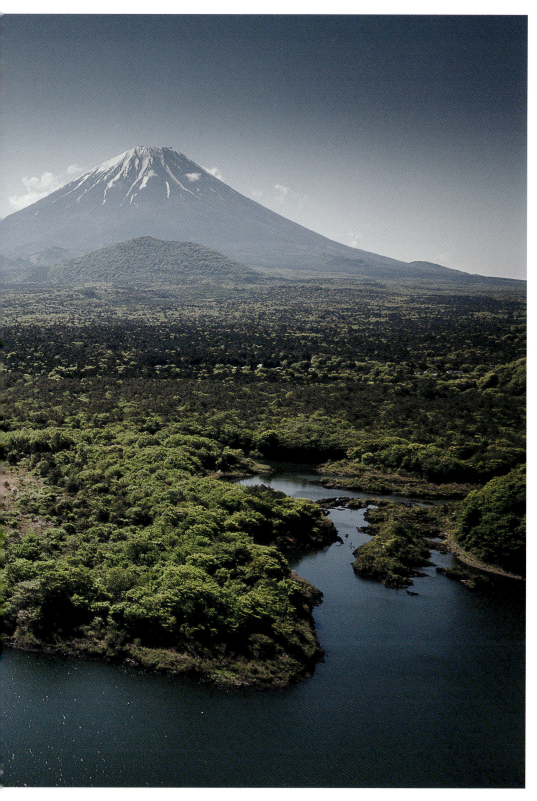

東京
(Tōkyō)

Tokyo

Previously known as the bustling harbour town of Edo, Tokyo is a city built on water. As the city changed, Edo became Tokyo, or the 'capital city of the east', but its multiple charms remained. Old canals still surround the Imperial Palace, running through the gardens of this landmark architectural complex. And despite the horrors of the Second World War, the latter has retained an energy that gives unprecedented modernity to the capital today.

Nowadays, Tokyo extends its boundaries from the eastern coast of Honshu Island to the slopes of Mount Fuji in 23 special wards, each with its own strong identity.

The megalopolis is home to many currents of sensitivities and fashions: from the luxury boutiques of Ginza and the bustling Shibuya, via Shinjuku and its train station visited by 3.5 million daily travellers, to Harajuku, the epicentre of manga culture.

In addition to its backbone of efficient and punctual subway and train lines, Japan's capital city has built its reputation on countless skyscrapers and towers, such as the Tokyo Tower and Tokyo Skytree, which dominate the city despite the significant risk of earthquakes.

To understand the city, you should climb its towers to admire from afar the luxuriant gardens of the Imperial Palace and Togu Park, the residence of the heir to the throne, or discover, in the distance, the majestic Mount Fuji and its snowy peak. However, some attractions are better explored closer up, particularly the many temples and parks, such as Shinjuku Gyoen, a perfect illustration of a Japanese tradition that is still very much alive.

The capital's numerous inextricable footbridges, bridges, and crosswalks with insane geometric shapes bring a dizzying sense of possibility while at the same time forcing admiration, just as commuters feel when they take the automatic aerial metro on the city's Rainbow Bridge to the futuristic district of Odaiba.

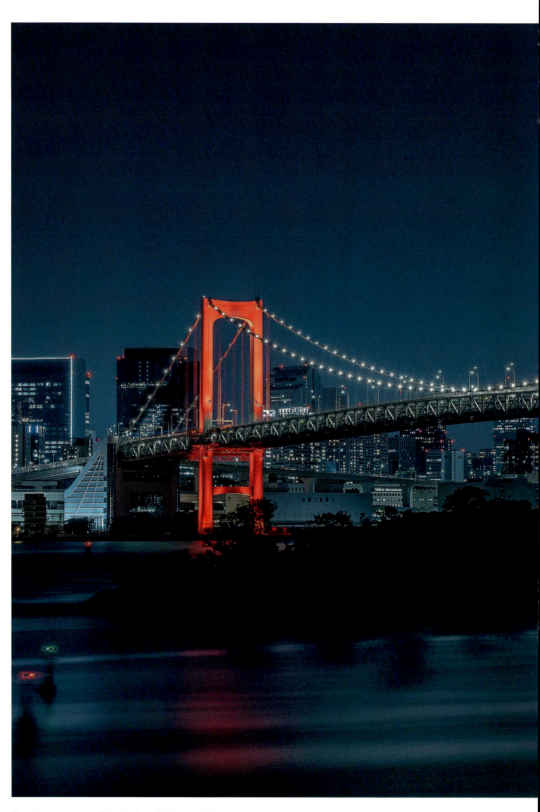
The changing colors of the Rainbow Bridge, over Tokyo Bay

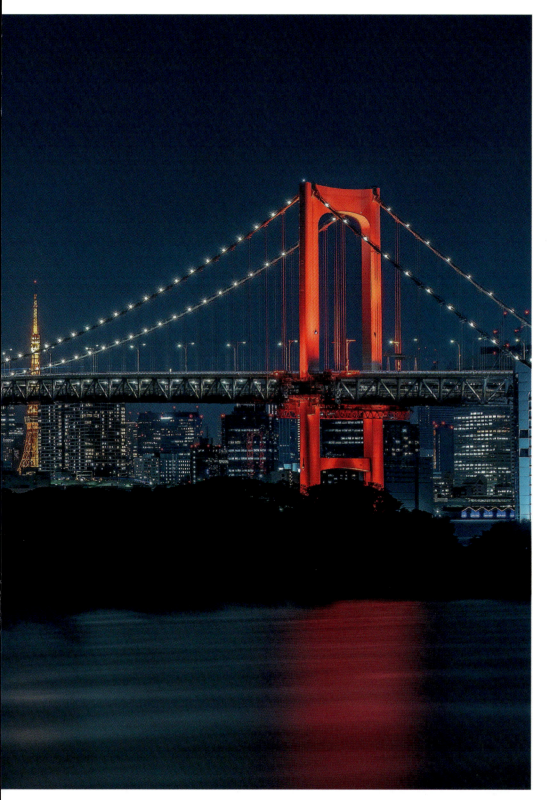

Meguro-gawa and its banks full of cherry trees, in Meguro district

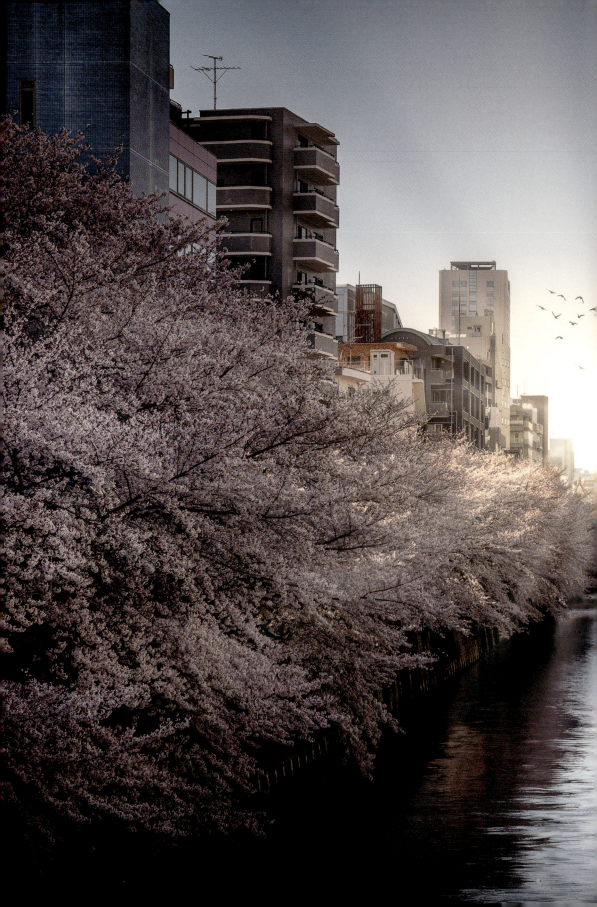

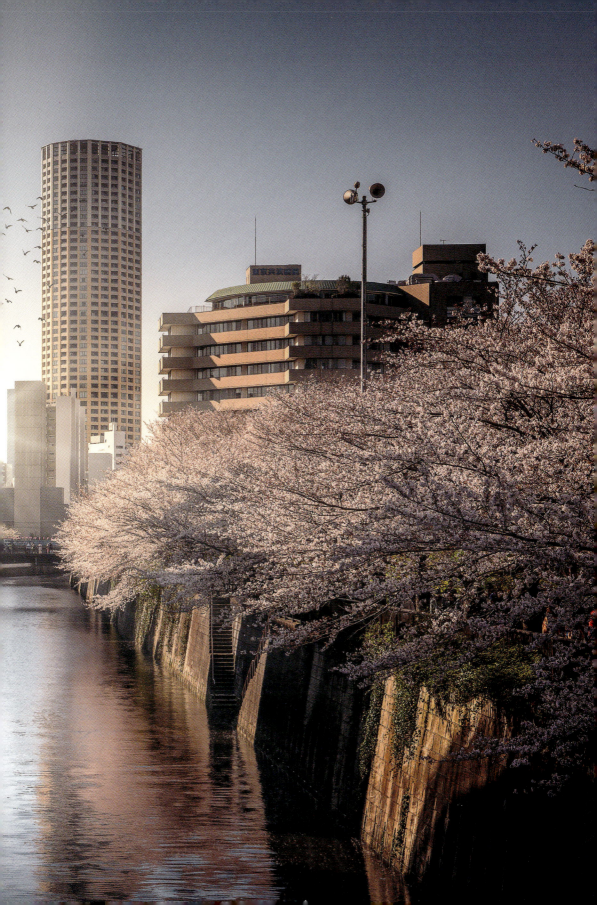

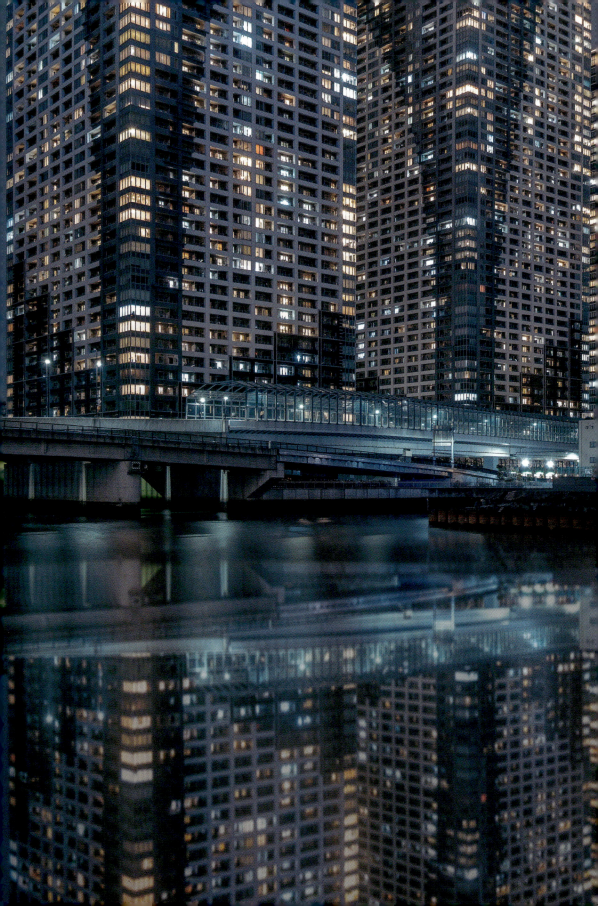

Tokyo

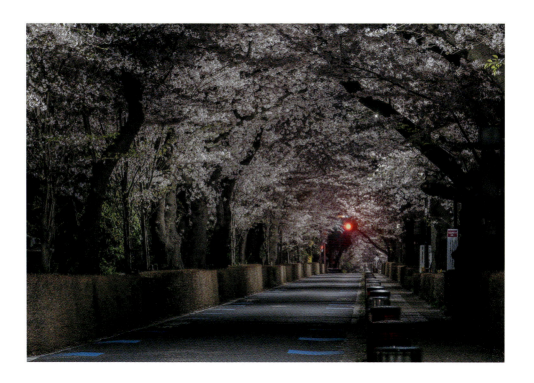

An example of Tokyo's large waterfront housing developments in Kachidoki area

A quiet night in the cemetery of the district of Aoyama

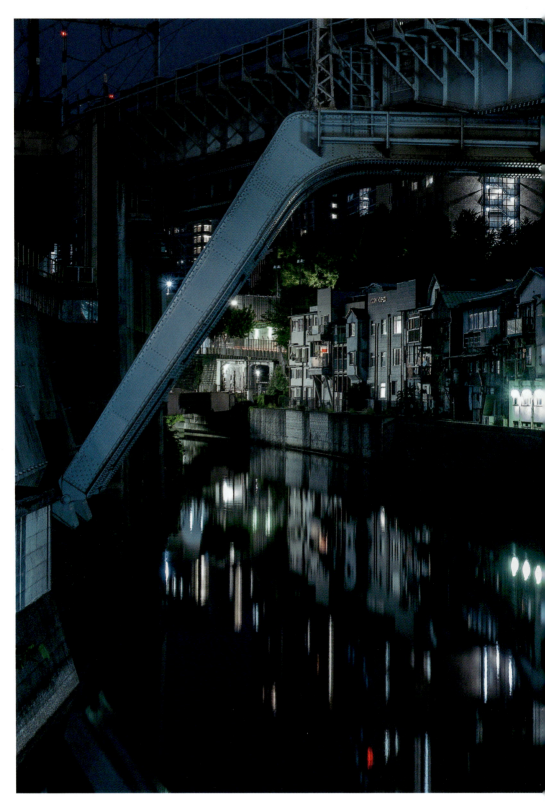

The populated bank of the Kanda River that crosses the city

Tokyo

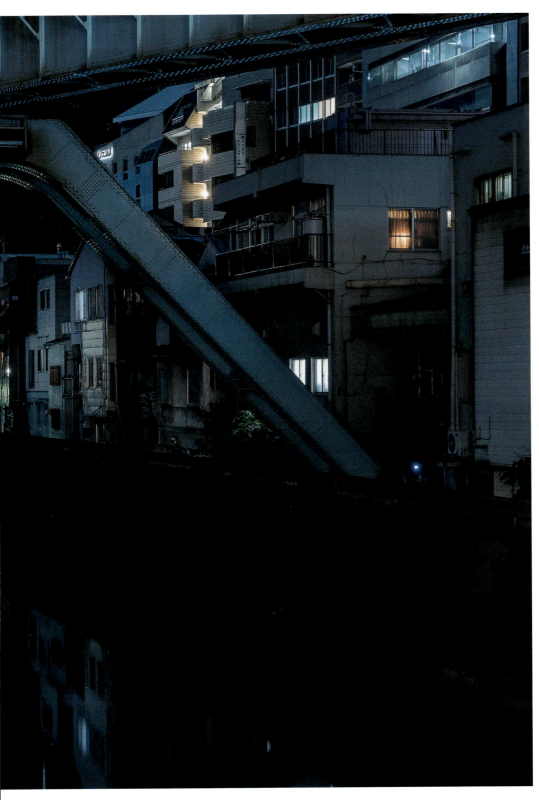

Tokyo

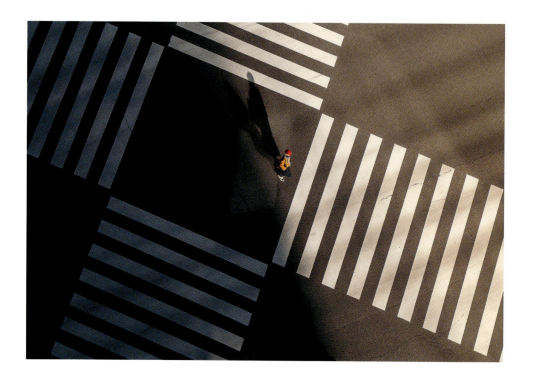

Geometry in Ginza, Tokyo's upscale district in Chūō Ward

Biking under the Tokyo Skytree in Sumida Ward

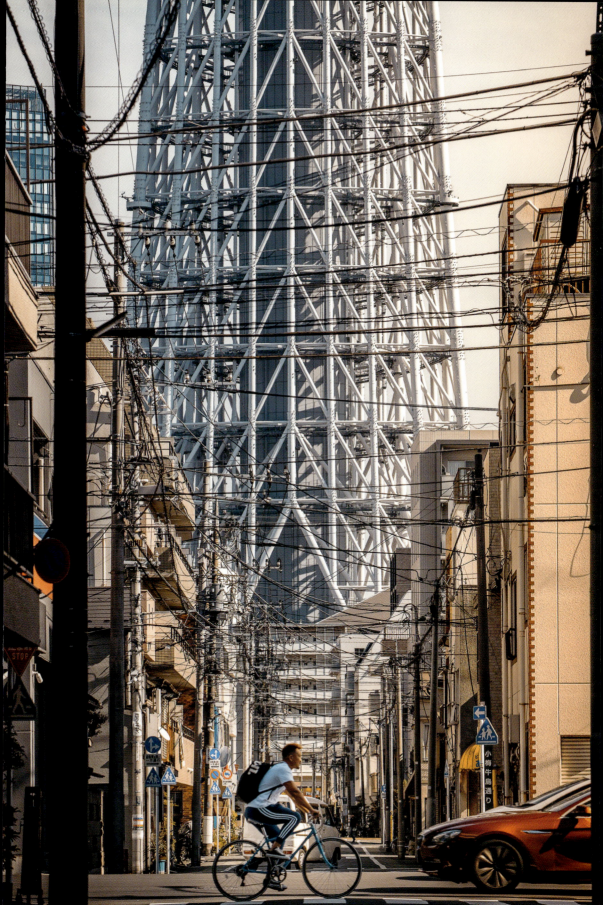

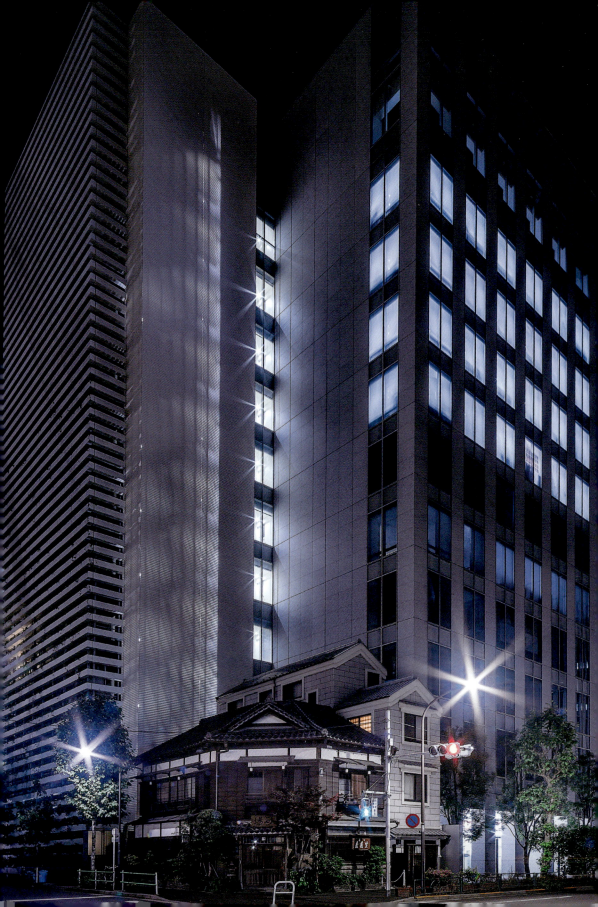

Tokyo

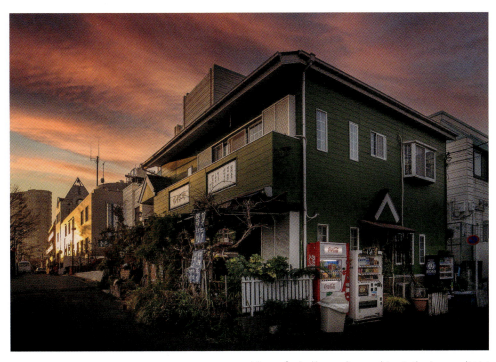

A house flanked by vending machines in the Aoyama district (Minato-ku ward)

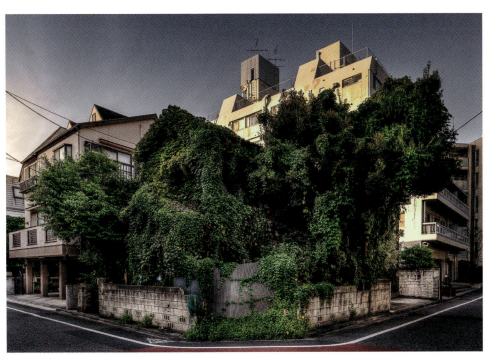

◀ An example of the mix between traditional and hypermodern architecture in Tokyo in the business district of Toranomon

Greenhouse

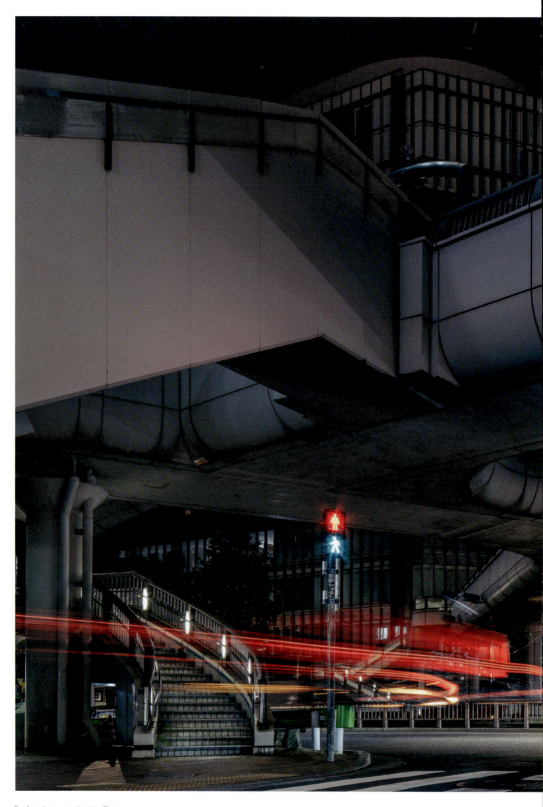

Pedestrian crossing in Ginza

Tokyo

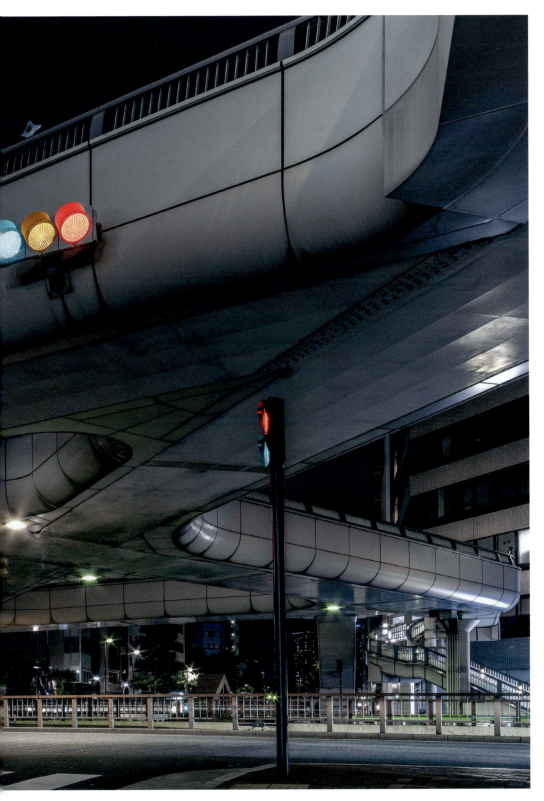

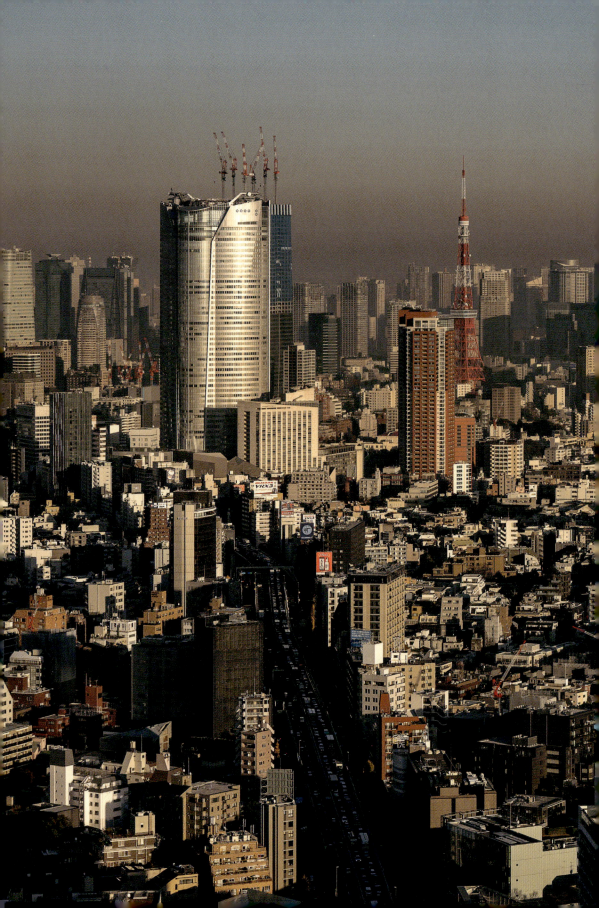

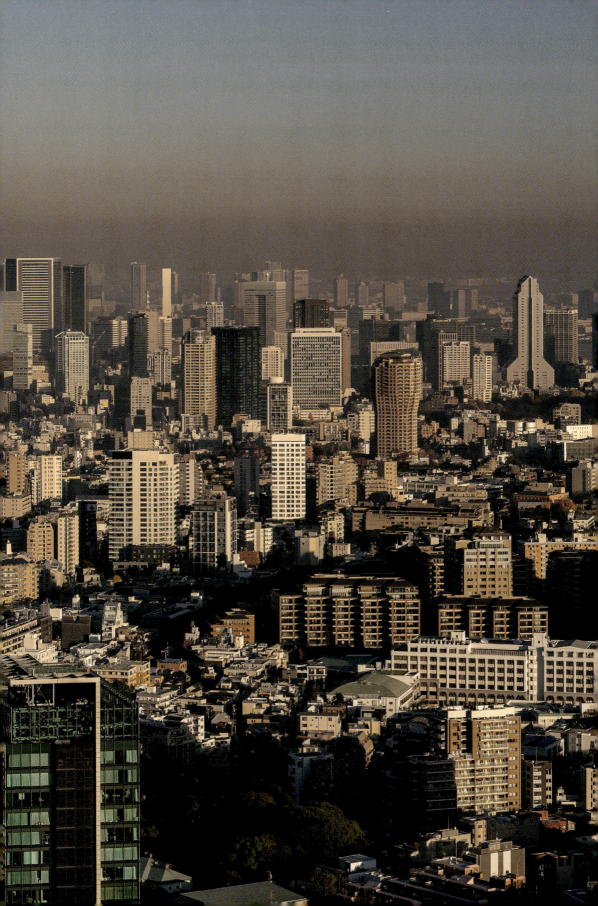

Tokyo

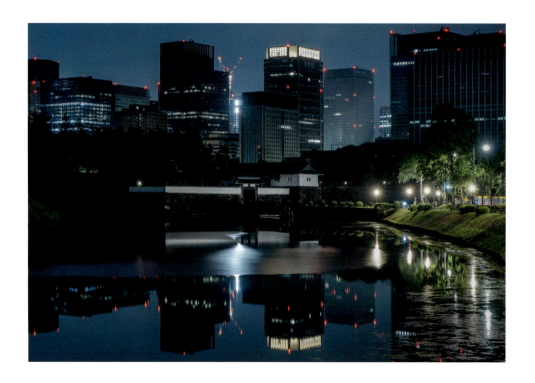

Around the Tokyo Imperial Palace,
Chiyoda district

The Tokyo Gate Bridge ▶
over Tokyo Bay

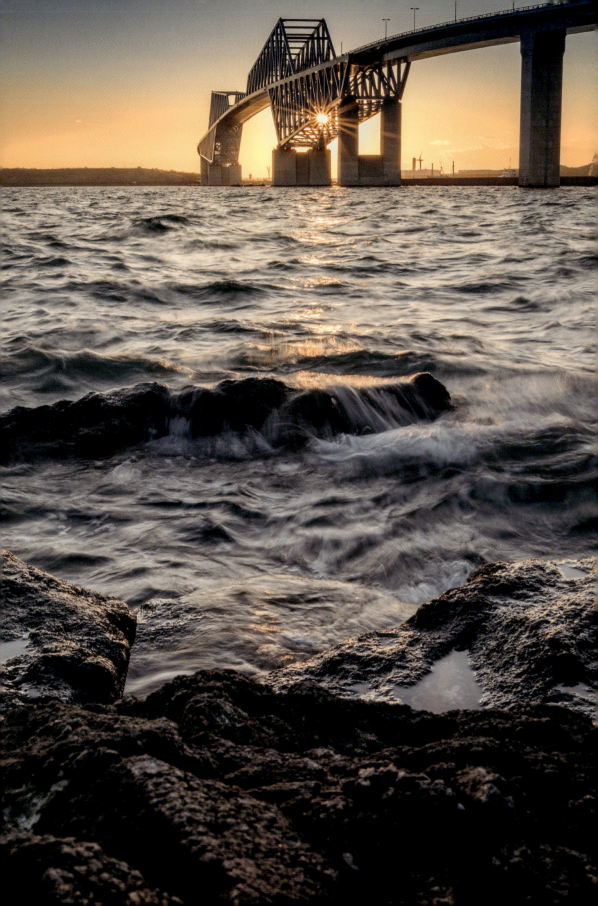

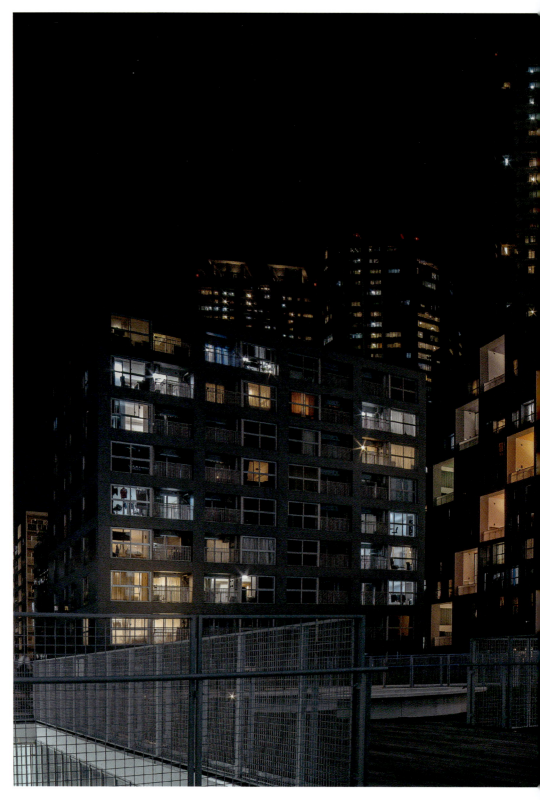

Colorful residence of Tokyo's artificial islands

Tokyo

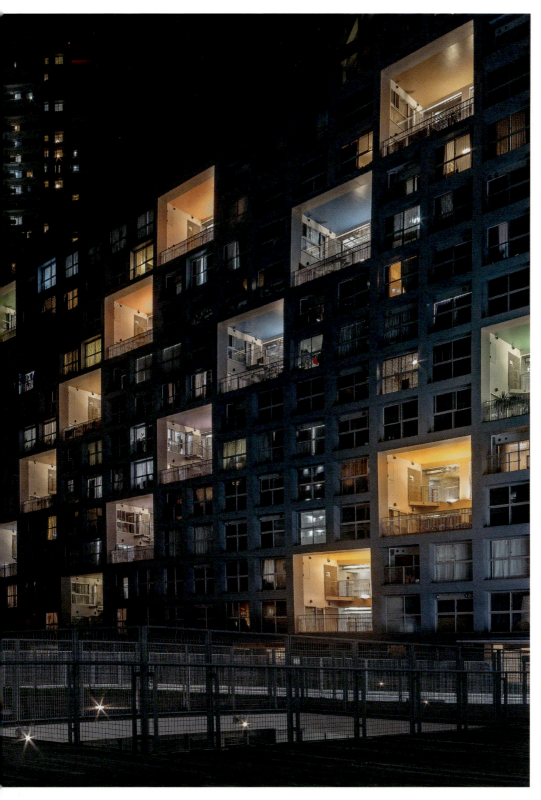

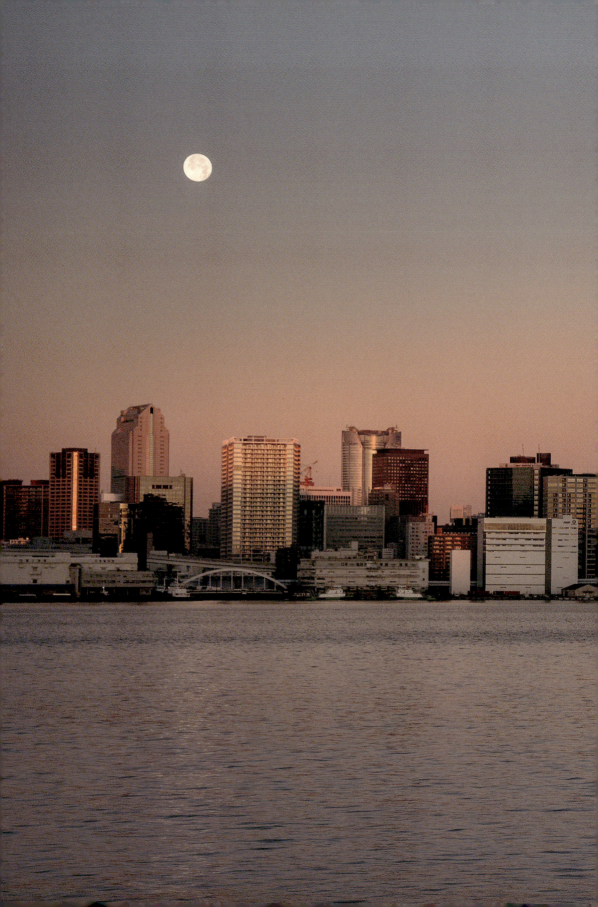

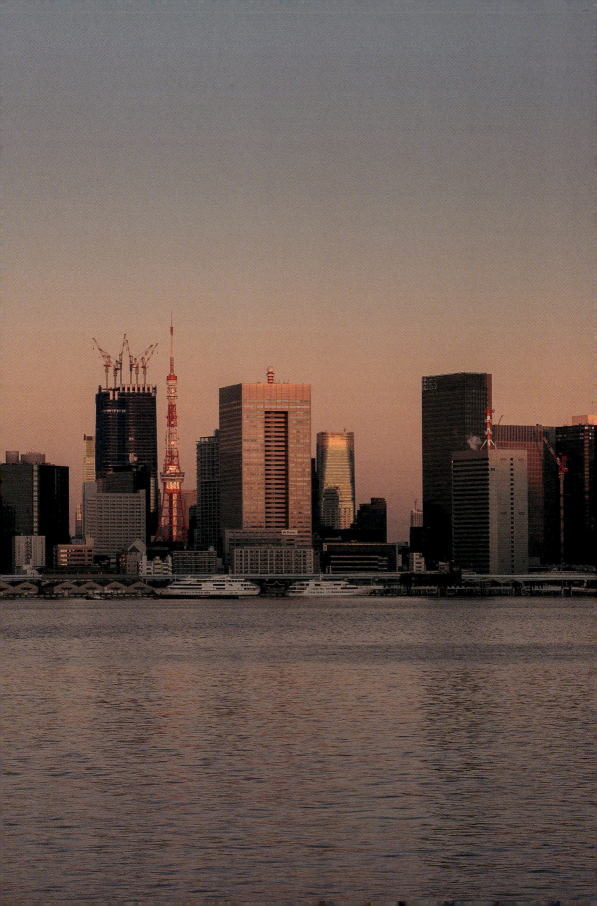

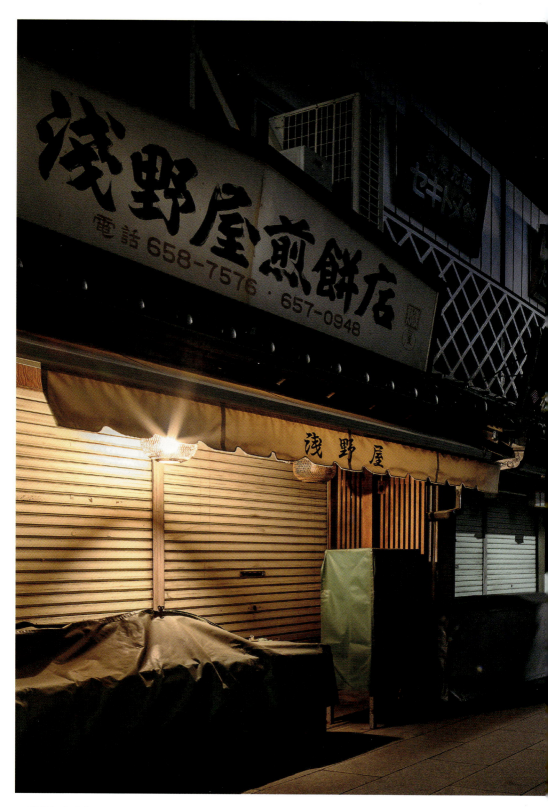

◀ Tokyo's skyline

Tokyo

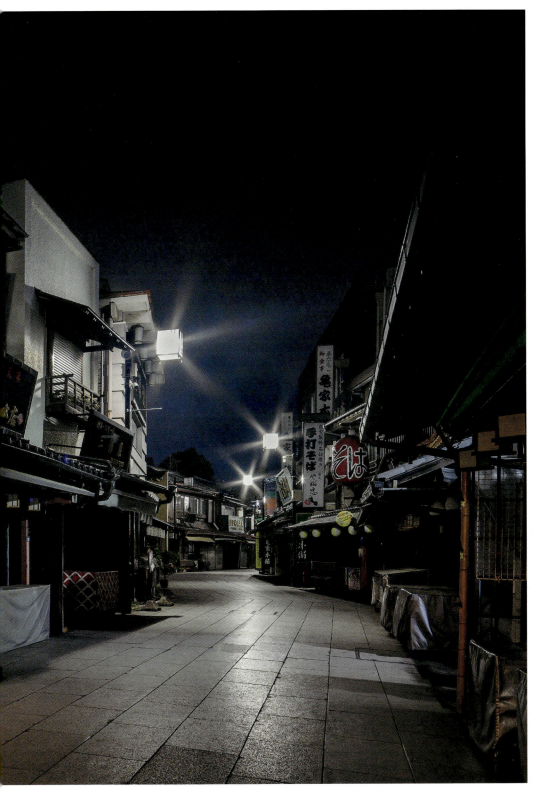

Serenity at night in the shopping streets of Shibamata, a traditional district

Tokyo

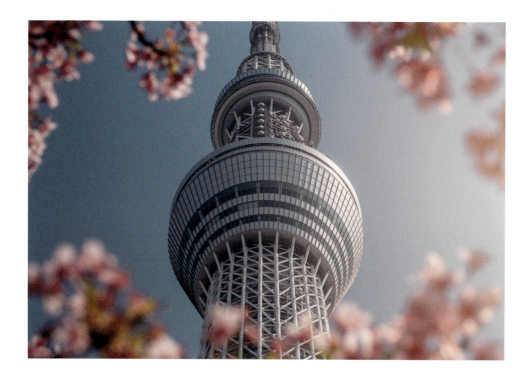

The top of Tokyo Skytree

Night scene under the bridges of Takadanobaba ▶

Asakusa Tokyo

浅草

(Asakusa)

On the fringe of Tokyo, the district of Asakusa is best known for its Buddhist temple Sensō-ji.

Located at the end of a long alley lined with a myriad of small shops – some of which are real tourist traps – this magnificent building dedicated to the goddess Kannon is inseparable from the majestic five-storey pagoda to its left. It's a life-size postcard on contemplation and meditation, a place whose mystical atmosphere favours introspection: one notices these tourists who, although they are not initiated in Buddhism, mingle with the regulars to burn a stick of incense or to draw a wish for the year to come, provided they respect the advice of wisdom that accompanies it.

Often compared to Old Tokyo for its more traditional atmosphere and its rickshaws (or *jinrikisha*, in Japanese) that you can see by the dozens, Asakusa is nevertheless a very popular district for tourists thanks to its many hotels (often less expensive), its restaurants and its multitude of handicraft shops.

In fact, it is impossible not to linger on the famous Kappabashi-dori, a street that attracts restaurant professionals with its countless kitchen utensil stores. There, you will find row upon row of striking 'sample foods', the fake dishes made of wax or resin that are used in local restaurants to present appetizing menus.

'The golden turd'

It is worth taking your time in Asakusa, the unofficial capital of Tokyo cuisine, to taste its delicious melon pan – a type of very light bun that doesn't necessarily taste like melon – before discovering the Hanayashiki amusement park. Dating from the middle of the 19th century, it houses thrill rides as well as cafes and the famous... 'golden turd', an unflattering nickname that Tokyoites have given to the flame at the top of the headquarters of the Asahi brewery. According to its architect, Philippe Starck, this flame represents beer foam.

If you enjoy the neighbourhood, take a step up to admire it differently. To do so, head to Oshiage and the famous Skytree, located a subway stop away (or 1,500m on foot) and surrounded by shopping malls. At the top of this 634m-high tower, which serves as a radio antenna, you will have a breathtaking view of Tokyo and its surroundings, from Asakusa to Mount Fuji.

As often in Japan, a trip of only a few minutes is enough to discover different aspects of the country, between history and modernity.

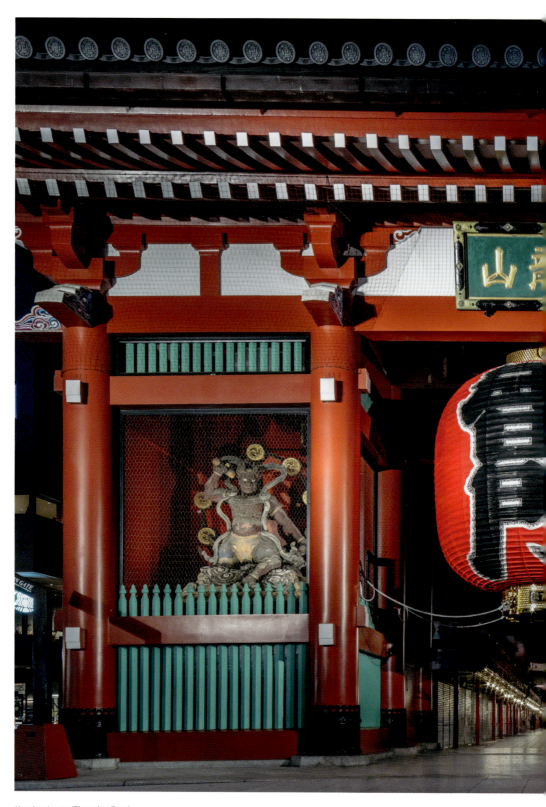

Kaminarimon, 'Thunder Gate'

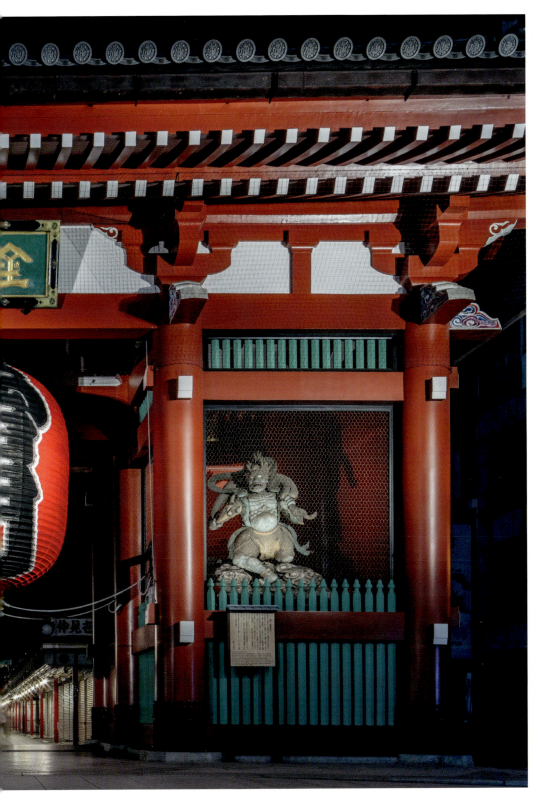

Asakusa

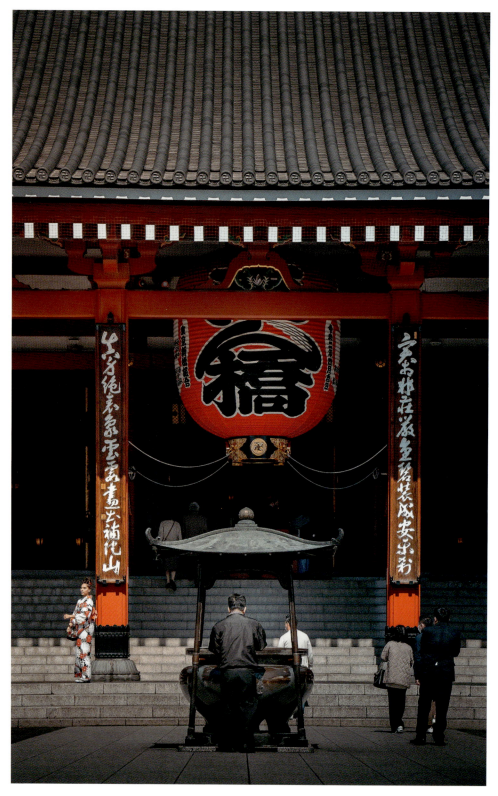

Buddhist ritual in front of Sensō-ji Temple

The pagoda of Sensō-ji, the oldest Buddhist temple in Tokyo ▶

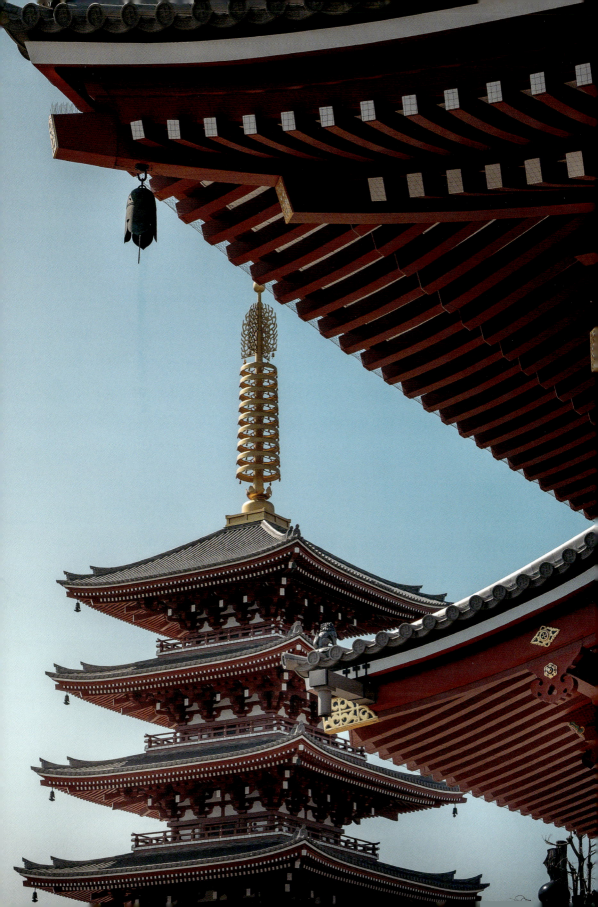

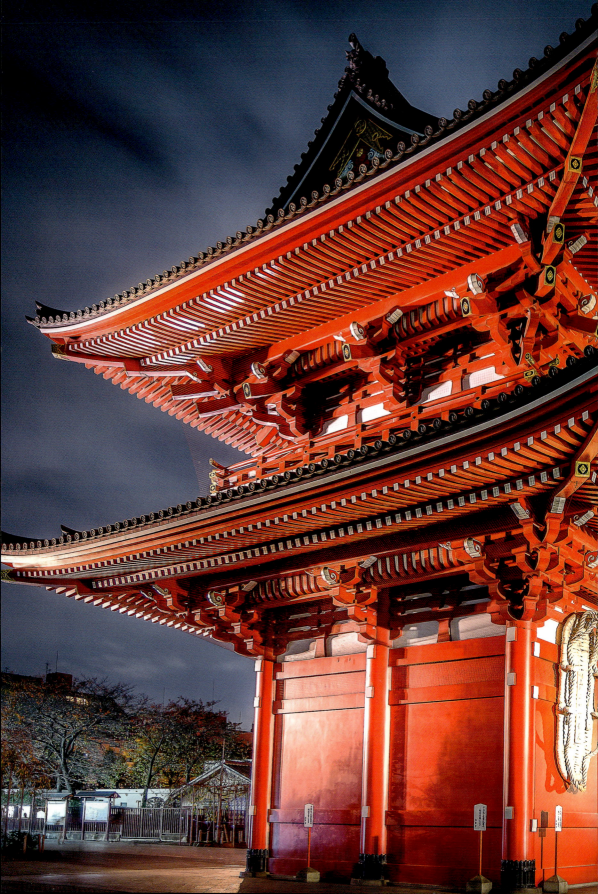

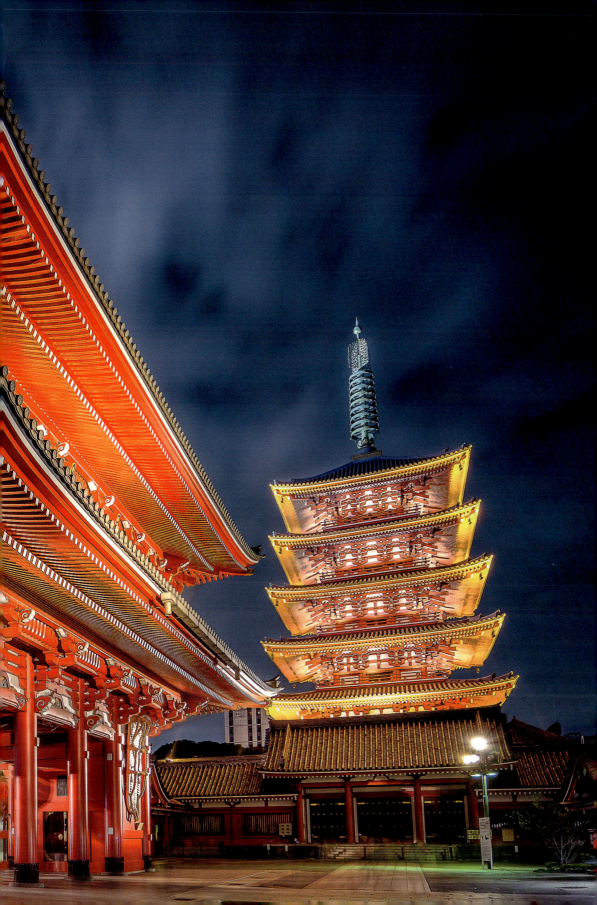

◀ Sensō-ji by night

Shinjuku Tokyo

新宿
(Shinjuku)

Located west of the Imperial Palace, Shinjuku has been one of the major nerve centres of Tokyo since the 17th century. The largest district of the capital, it is very lively day and night, yet presents two very different faces, between gigantism and sobriety.

The larger end of the scale is illustrated by its huge station and its colossal towers, similar to those of Tokyo's City Hall and which, in some ways, seem to be inspired by Notre-Dame de Paris. At least that's what their architect, the Japanese Kenzō Tange, states.

But Shinjuku also retains the sobriety of pre-war Tokyo, symbolised by its maze of tiny alleys, lined with pocket-sized bars and restaurants.

Lively district

The business centre is even more elusive at night, when the suits-and-ties give way to a much more unrestrained youth. The Kabukicho area is known as the capital of debauchery, yet it is possible to walk around its busy streets without fear.

So don't be scared, go ahead and stroll along Yasukuni-dori, the main artery of the district, to discover its izakaya (traditional bistros), its yakitori (skewers) stalls as well as its shops and stores illuminated day and night.

In Shinjuku, whether you like flashy cabarets or small bohemian bars, there is something for everyone!

A unique train station

What makes Shinjuku famous is above all its station: the biggest in the world, with no less than 3.5 million users passing through it daily. In total, some 25,000 trains pass through there every day, almost one train every three seconds!

In this gigantic hub of metro lines and railroads, schedules are sacred. Therefore, they are followed to the second. Punctuality is a must, since any delay, however small it may be, causes a chain reaction in the entire Tokyo traffic.

You must have observed the organisation of this anthill of workers, from the train conductor and the ticket office assistant to the cleaning staff, to understand all the efforts made so that no delay occurs. Only an earthquake or a typhoon could neutralise this magnificent human teamwork.

A real city within a city, the huge corridors of Shinjuku Station form multilevel streets with stores, cafes, restaurants and malls. Its perfect organisation brings a feeling of security and calm that never leaves us.

However, be careful when you choose your exit... As you try to get out of this labyrinth, you should know that there are more than 200 of them.

A symbol of Japanese railway expertise, but also of effort, respect for others, and Japanese collective discipline, Shinjuku station is far from being an exception in the archipelago. Indeed, the first 23 busiest stations in the world are Japanese.

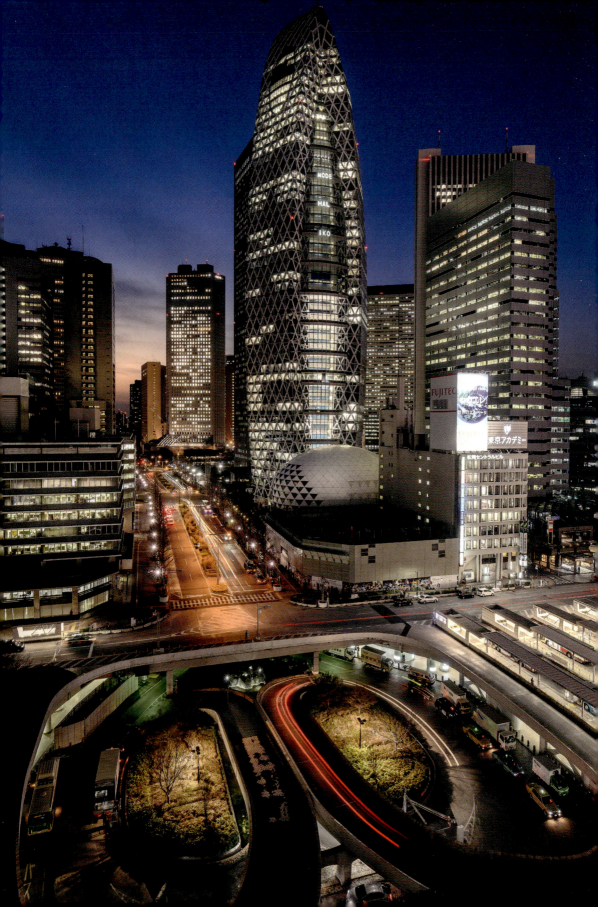

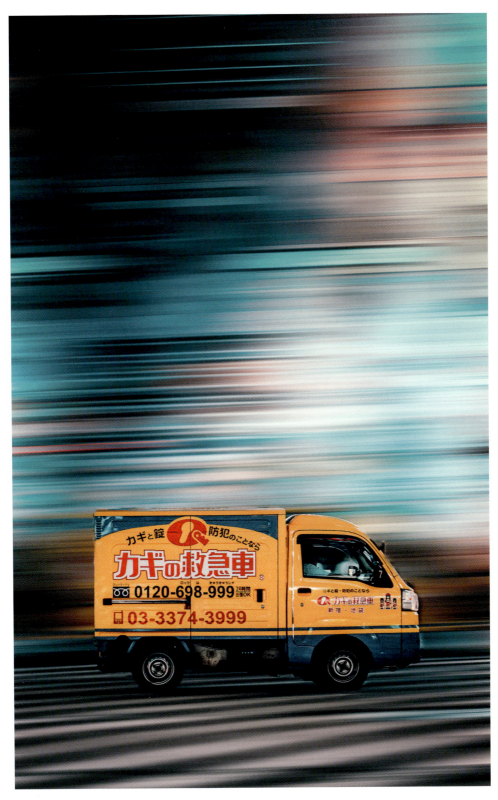

The Cocoon Tower in Shinjuku and its fashion school

Beep-beep 'niaooooowww'

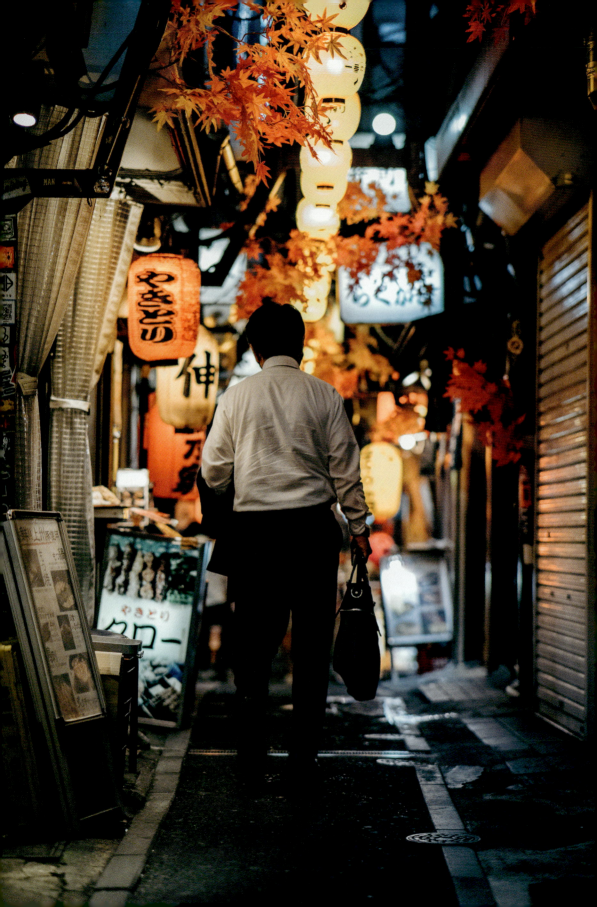

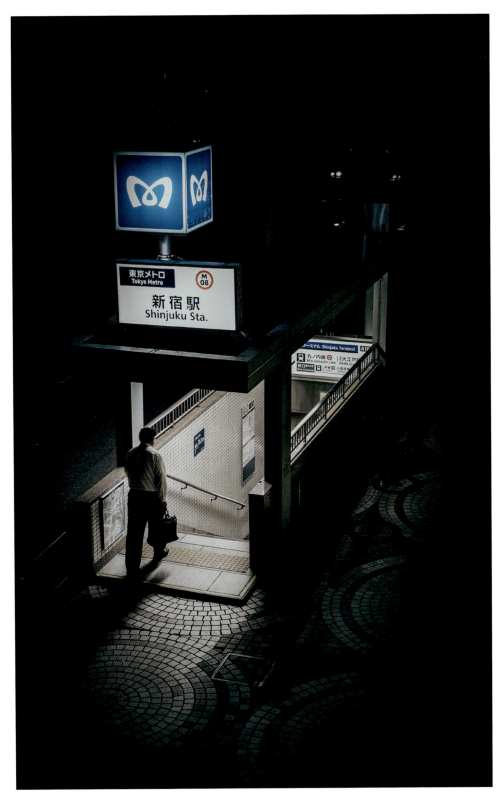

◀ Work is over for this salary man in the alleys of Omoide Yokochō

On the way home, through one of the more than 250 entrances of Shinjuku Station

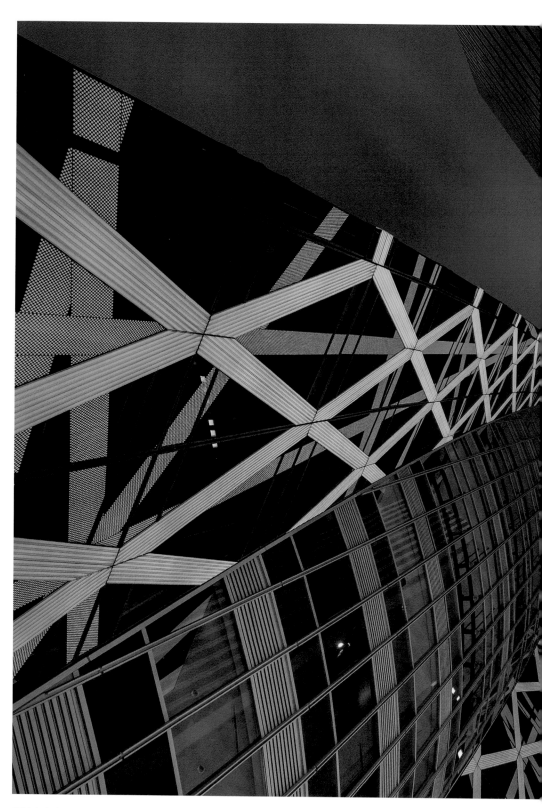
Shinjuku's skyscrapers

Shinjuku

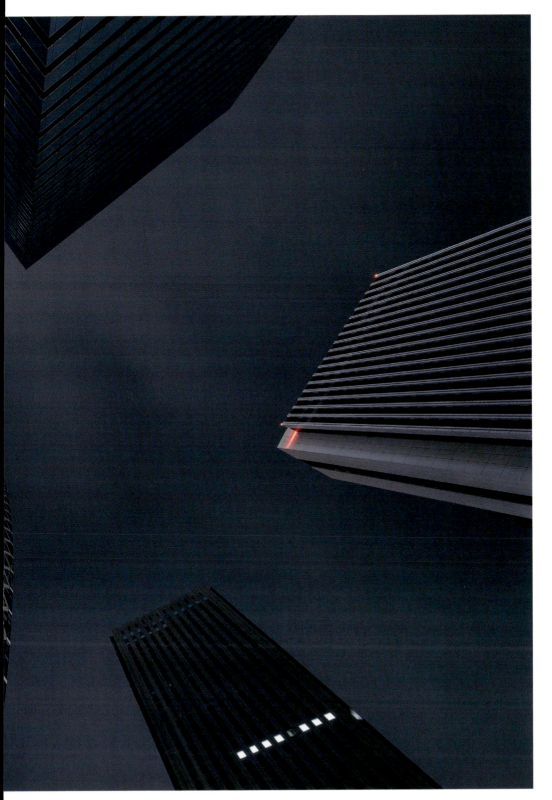

Shinjuku

Shinjuku Gyoen's park ▶

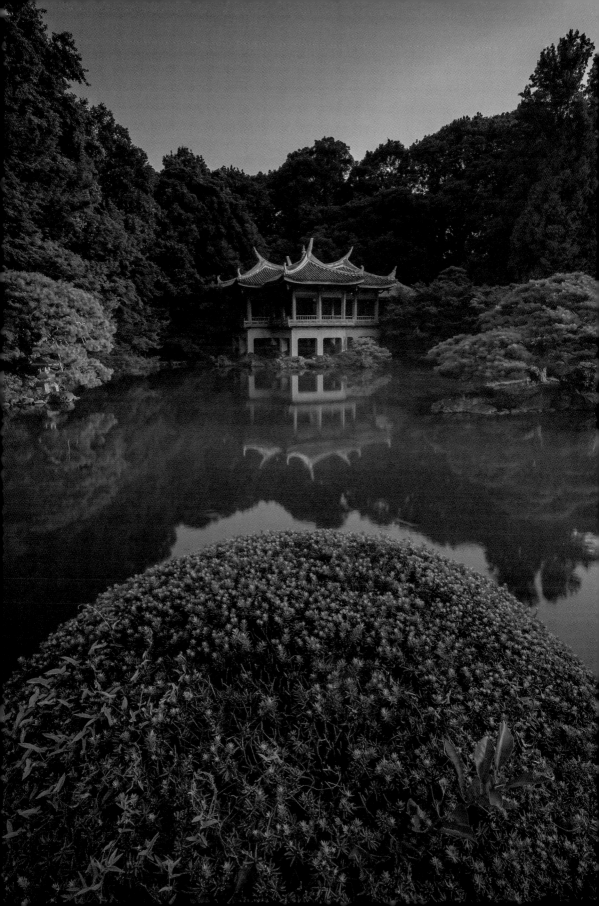

Shibuya Tokyo

渋谷

(Shibuya)

Just outside the station is the famous Shibuya Crossing, known as the busiest intersection in the world.

It is a sight to behold! To apprehend the frenzy of Tokyo, you just have to see for yourself this swarm of pedestrians, crossing each other without jostling, and stopping as soon as the light turns red before starting again at the green light, their eyes riveted to their mobile phones.

Very popular among foreign media and filmmakers, Shibuya is now one of those landmark places, photos and videos of which are shared extensively on social networks.

But more than a giant crossing, it is also there that beats one of the hearts of Tokyo, which, at night, glitters with a thousand neon lights and giant screens.

Shibuya is also the starting point of several walking tours, whether it is to the Omotesando neighbourhood, to the Dior building, the Tod's building, or the Prada building, but also to the magnificent Delvaux boutique, or the city's numerous museums.

Hachikō the dog

Before you rush into the district, stop for a moment of sweetness in front of the statue of the dog Hachikō, whose name is on one of the exits of the station.

Japanese people love this animal and its story, which inspired the movie *Hachi* with Richard Gere, and dates back to 1923. At that time, a university professor lived near Shibuya with his faithful companion, who would follow him every morning to the station. In the evening, Hachikō would come back to pick up his master at the same place. One day, unfortunately, the professor died of a stroke at his workplace. However, the dog continued to go to the station exit every evening for nine years. When Hachikō died in 1935, he was buried next to his master in Aoyama Cemetery.

This moving story made the headlines, and a fundraiser was organised to build a statue of the faithful dog in front of the station, which became a very popular meeting point over the years. As a sign that Tokyoites are deeply touched by the strong bond between the man and his pet, a new statue was even unveiled in 1948 after the first one was melted down during the war.

From a more pragmatic point of view, Shibuya Station is a real city within the city with its department stores and hundreds of shops. Nearly 700,000 passengers use its ten subway or train lines every day, making it one of the main centres of attraction in the megalopolis.

Not far from there, the Sangenjaya district gives you a taste of the good life of the Japanese residential districts inside Tokyo, while Shimokitazawa, with its bohemian feel and vintage boutiques, seduces the young and the artists.

Shibuya

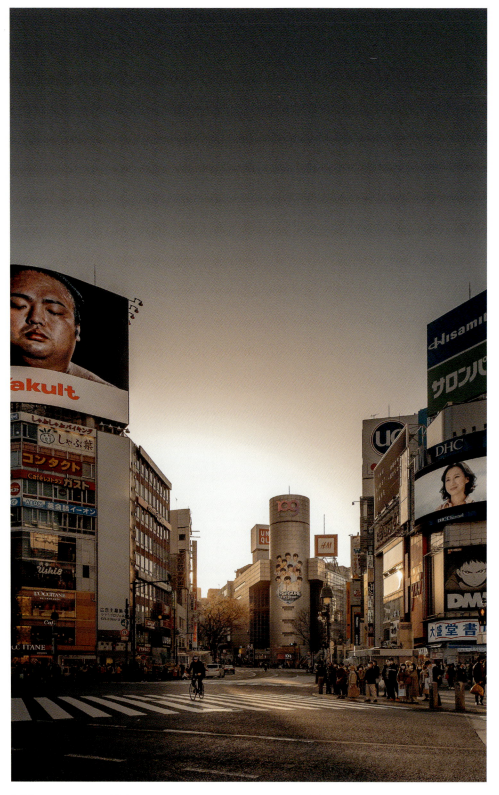

By bike, in a main street of Shibuya Shibuya, the world's largest intersection ▶

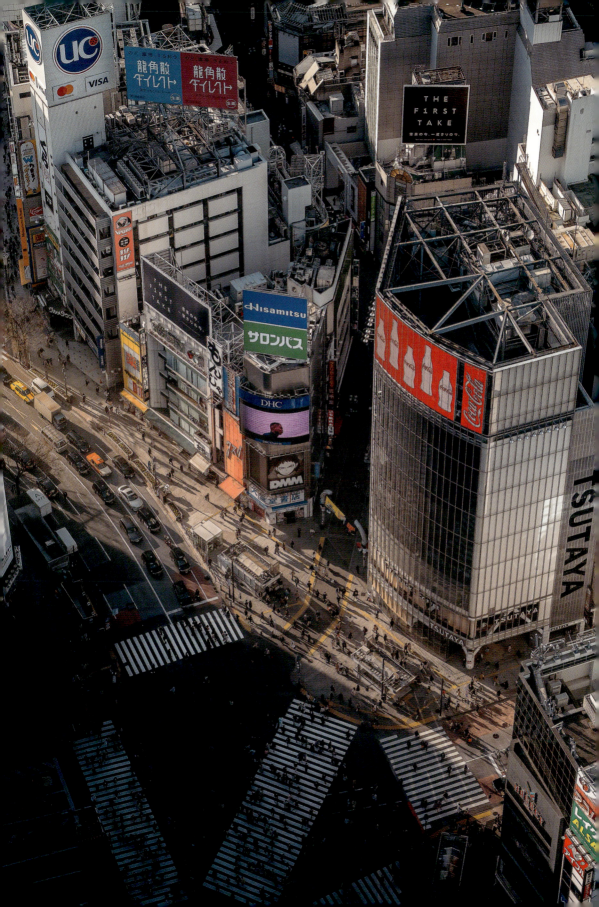

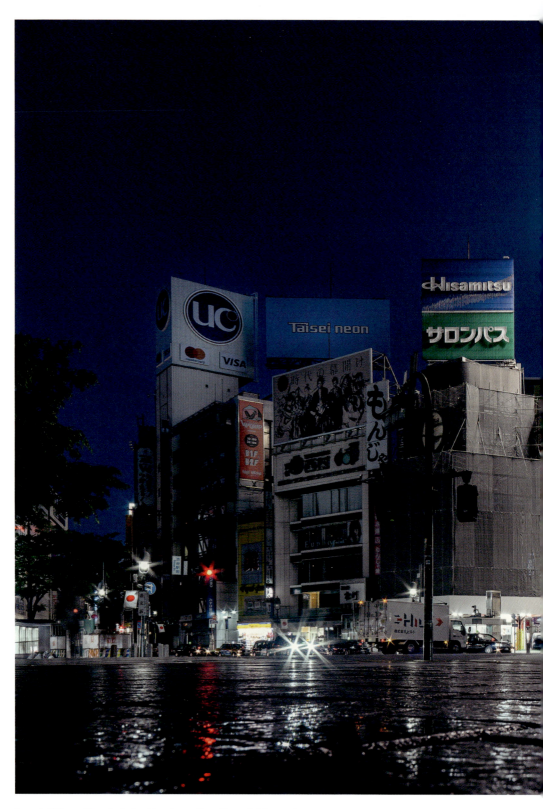

2 a.m. in Shibuya, the calm before the return of its millions of daily crossings

Shibuya

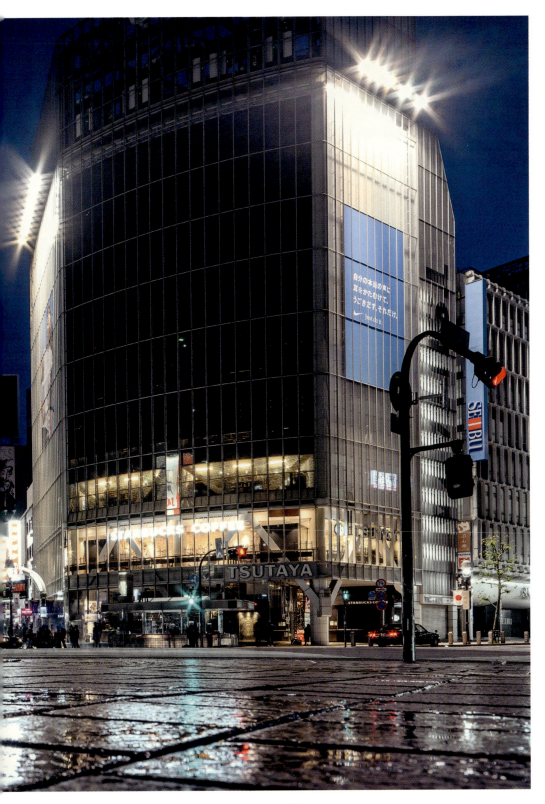

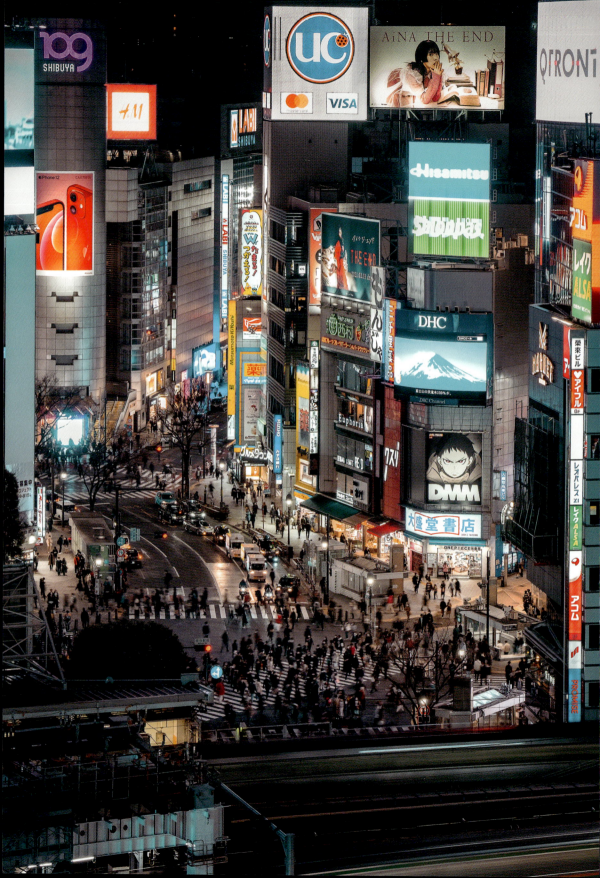

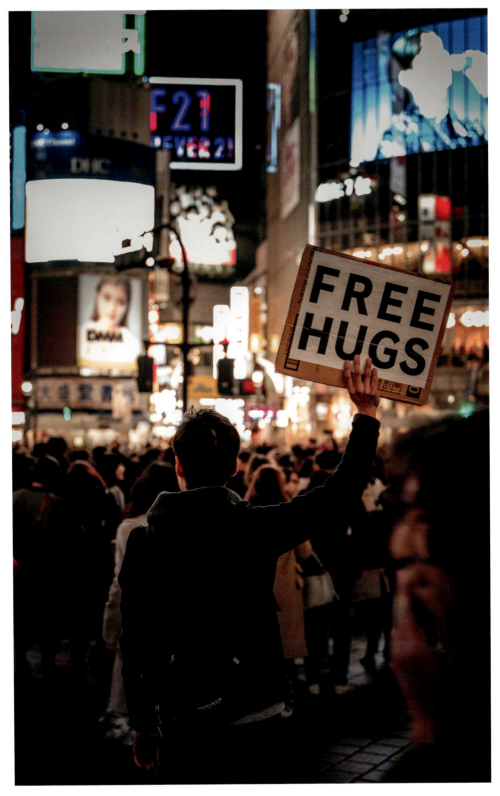

◀ Shibuya and its lights that never turn off

A man taking part in the 'free hugs' campaign in the crowd of Shibuya

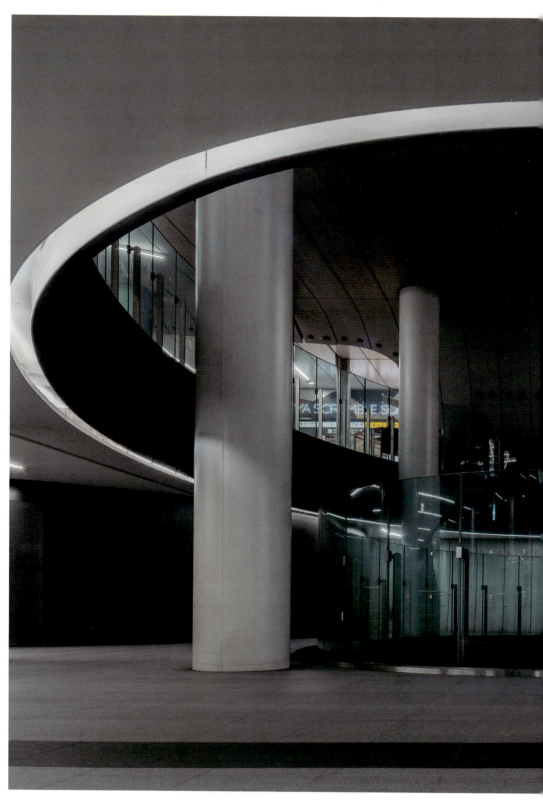

Architectural symmetry in Shibuya Station

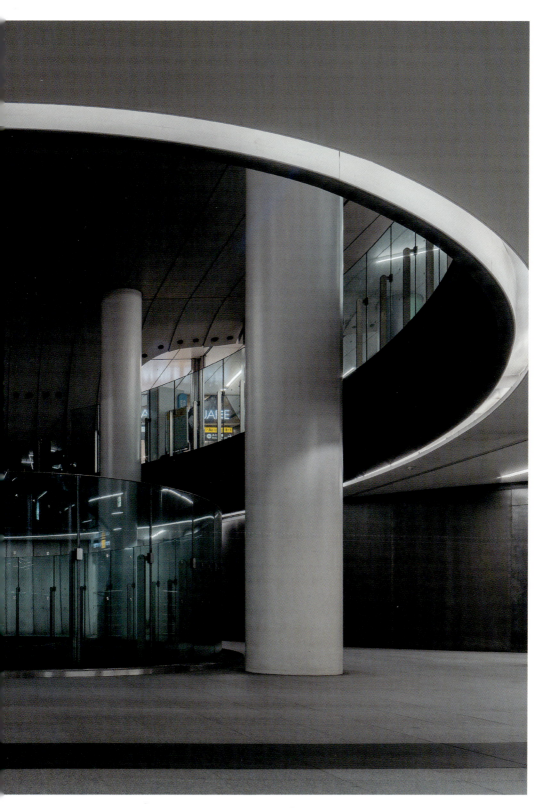

Akihabara Tokyo

秋
葉
原

(Akihabara)

With its electronic stores of all kinds, such as Yodobashi Multimedia Akiba or Tokyo Anime Center, its retro video game stores and its endless arcade terminals, Akihabara is certainly the most famous shopping district dedicated to the world of video games and manga in Japan.

Also called Akiba by some of its regulars, the place leaves no one indifferent with its crowded streets, colourful buildings and its thousands of neon lights and advertising screens.

The district has become an essential meeting place for all the geeks of the Japanese capital – the otaku as they are called in the country. It is also very popular among manga fans who, between trading cards and 'collectors' items, always find something to complete their atypical collection.

In Akihabara, you will also find something you have probably never seen anywhere else: maid cafés. In these typically Japanese bars, the waitresses wear uniforms inspired by those of maids. But don't be mistaken! If these 'maid' outfits may seem strange or even full of sometimes unhealthy undertones to Westerners, it is not so. Indeed, for the Japanese, these young girls are only doing a service to the geeks of the area, either by serving them drinks and other typical Tokyo delicacies or by distracting them with games or songs, karaoke being open until late at night.

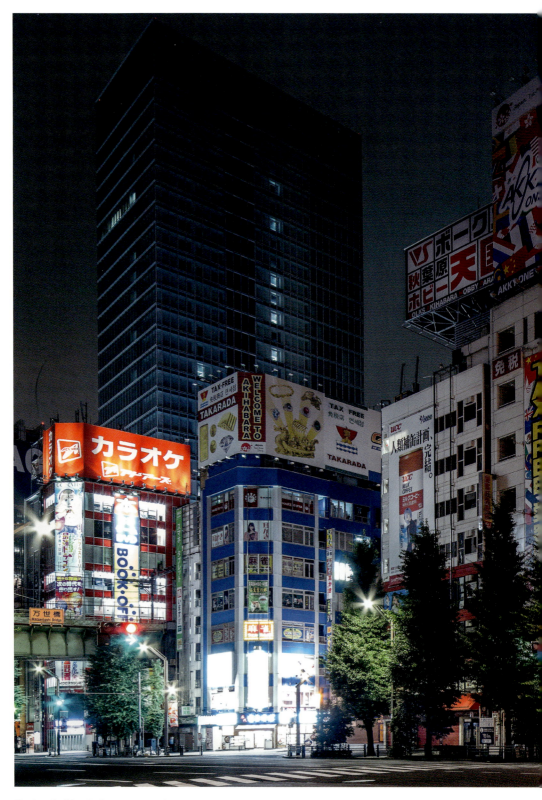

The Sega building (collector since April 2021)

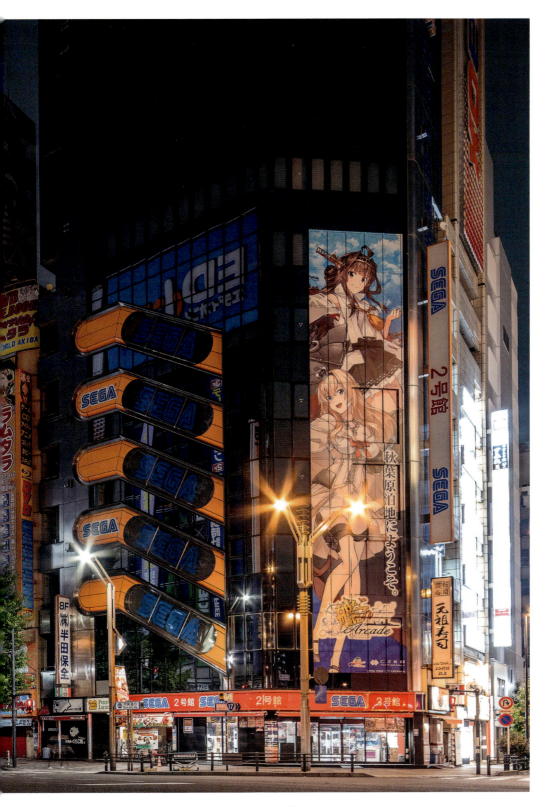

Akihabara

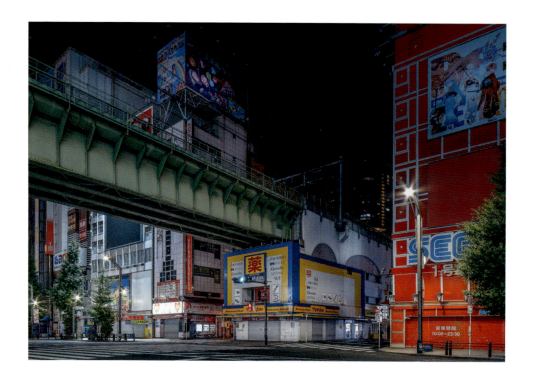

Under the Chūō-Sōbu Line, railway line connecting Mitaka and Chiba stations

Akihabara, also called Electric Town City, or the temple of geek culture

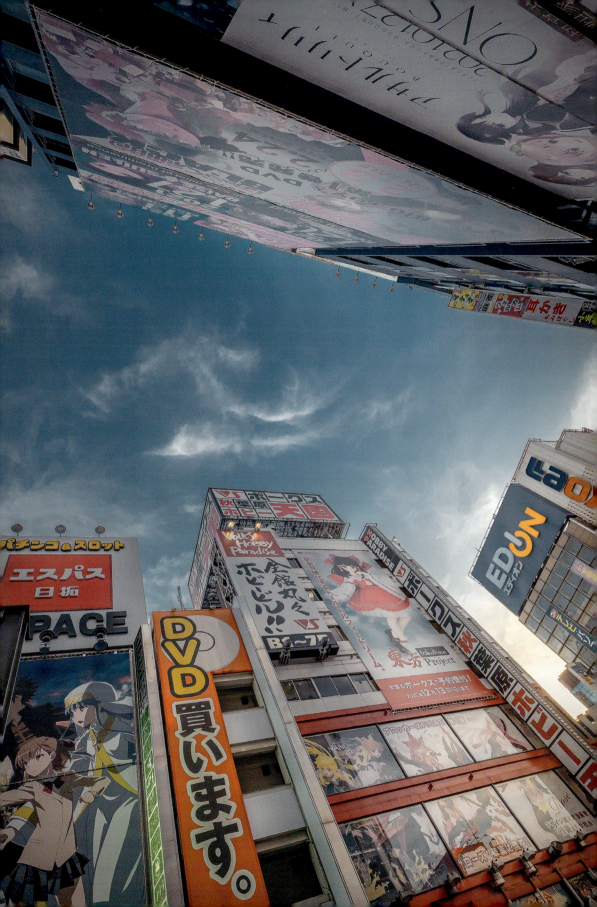

An atypical view of Akihabara, along the Kanda River

Akihabara

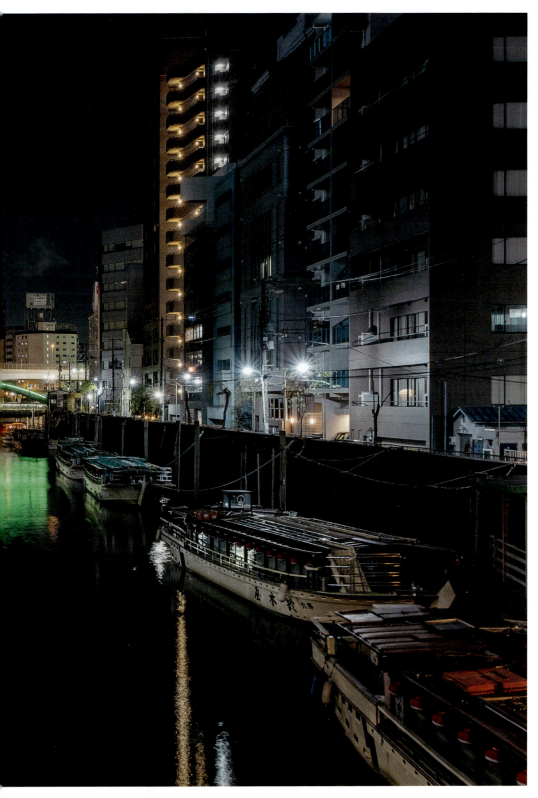

(Densha)

Train

With its fast, frequent, overly punctual, clean, safe, and comfortable trains, Japan's rail network is undoubtedly the most efficient in the world.

Japan Railways (JR) is the main company and operates, among others, the famous Shinkansen (bullet train), but there is also a wide range of private train companies that work just as well. A healthy competition that benefits the Japanese commuters: the Japanese companies are fighting to offer the best services, whether it is remote booking, quality of seats, or cleanliness of the toilets.

However, with so many different local, limited-express, and express trains, it's not always as easy as it seems. Once in the station, make sure to find your platform: the trains sometimes come and go in three minutes' time. And since they don't wait, make sure you quickly find your car, according to your class and reservation.

Things get even more complicated in the metro where the network, very similar to the train network, uses the same tracks in the stations! There is also the issue of having to take an express metro (which only stops at the biggest stations) or a classic metro depending on your destination.

A very useful pass

Although each station has its ticket hall, Japanese commuters all use a pass that is compatible with all railways in the country. This is easily explained…

Indeed, in Japan, you will always have to validate your ticket at the entrance and the exit of each station. The price of your trip depends on the mileage and the number of stations you travel to. So, the pass very quickly appears as more convenient and advantageous, even if it is always better to take a step back and evaluate the number of shuttles to take before getting on the first train or subway.

Still need help? There are ticket counters in all stations in Japan, where the staff is getting better and better at speaking English – a rare thing in Japan! They also act as a travel agency for long-distance trips.

A national passion

The Japanese railway network is the backbone of the island, linking its regions and inhabitants from north to south at dizzying speeds. The Japanese are proud of this network and have always had a strong relationship with the train. Be it in Hiroshima, for example, where the train was running only a week after the bomb – it is still the same train line that runs in the city today – or in Fukushima, where the train was the first means of transport to be revived after the disaster in 2011.

This national passion for trains is felt on a daily basis. On Sunday mornings, on a stroll, it is not uncommon to cross paths with dozens of Japanese people busy immortalising rails (of the Tōkyū Setagaya, for example) all over Japan. In large cities such as Tokyo, train and subway stations are now considered hubs (more or less important depending on the neighbourhoods and their population density) whose importance is increased by the establishment of shopping centres.

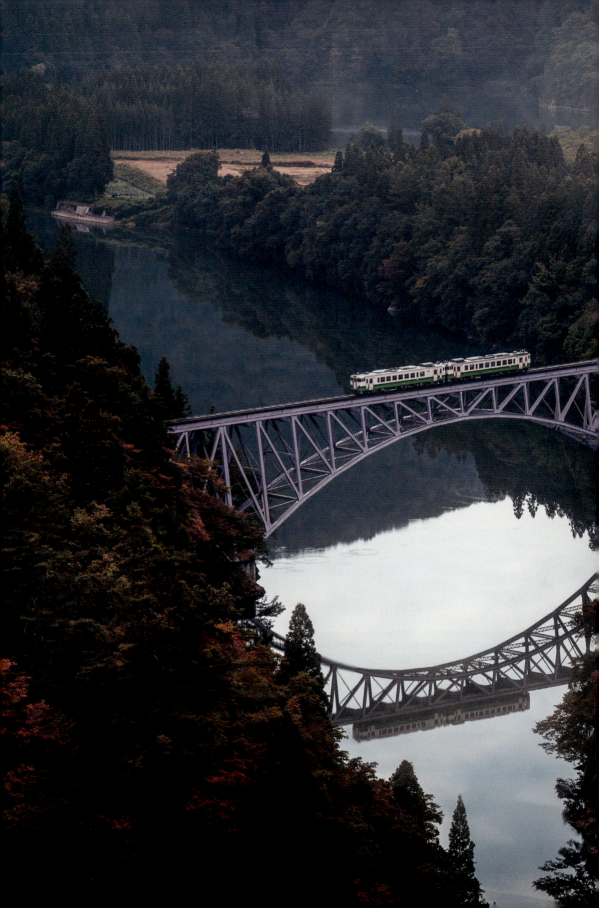

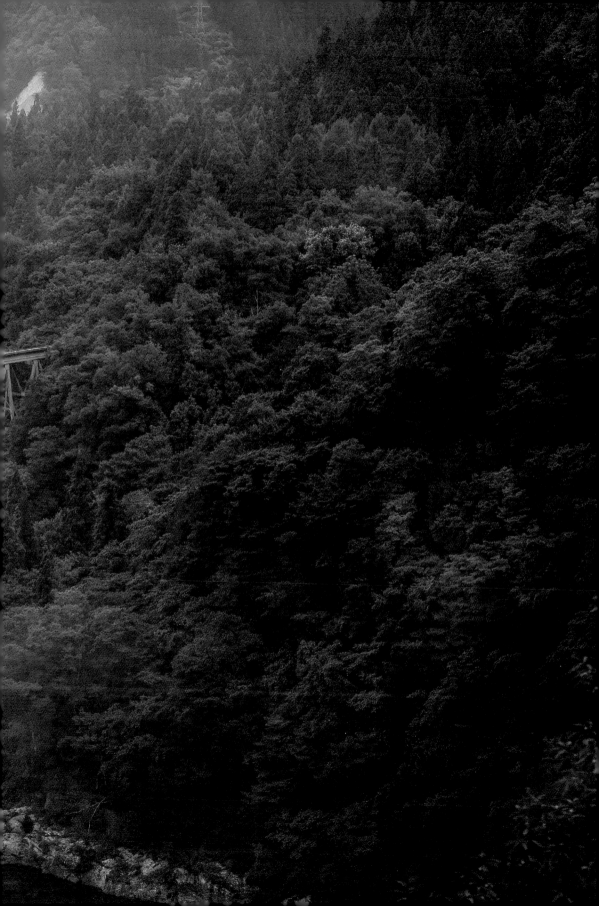

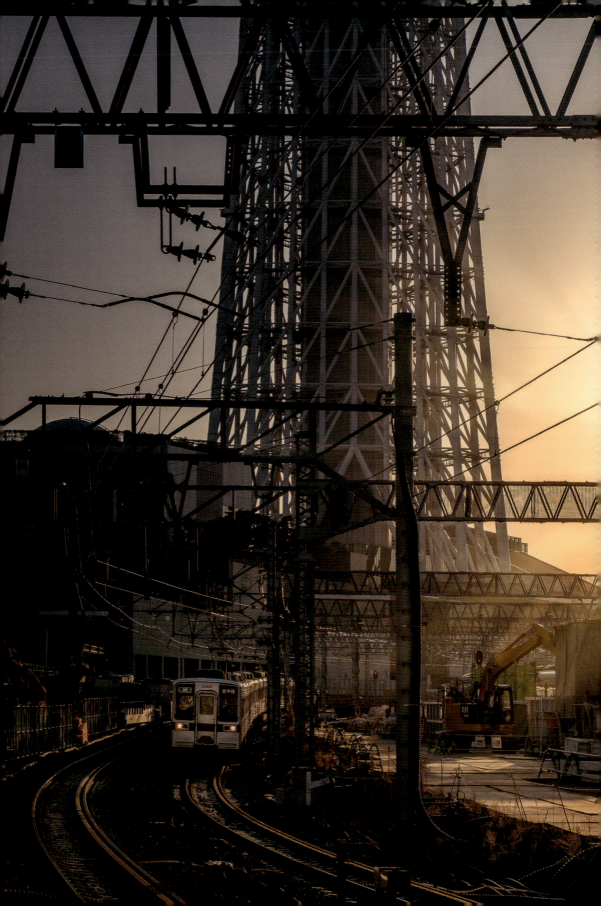

The omnipresence of the Tokyo subway

The express Chūō Line, the railroad line that connects Tokyo to Otsuki

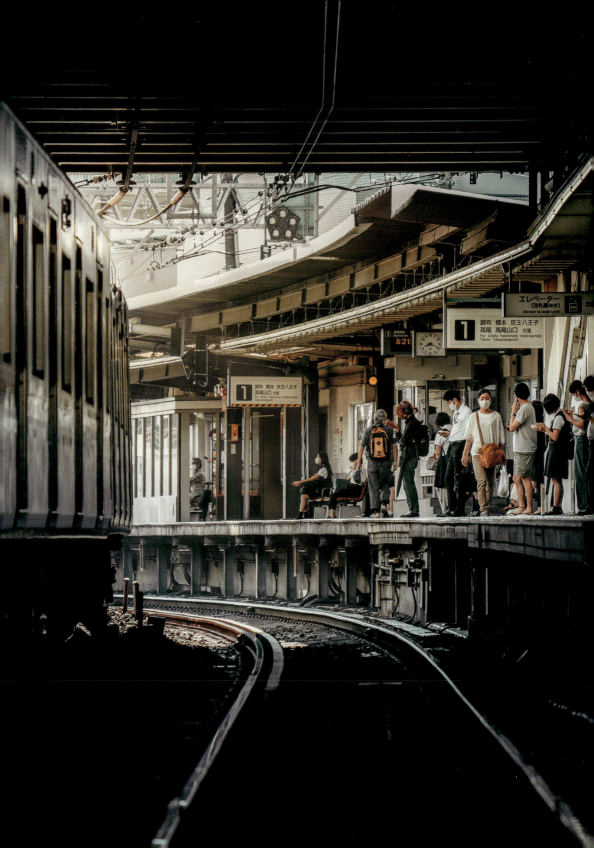

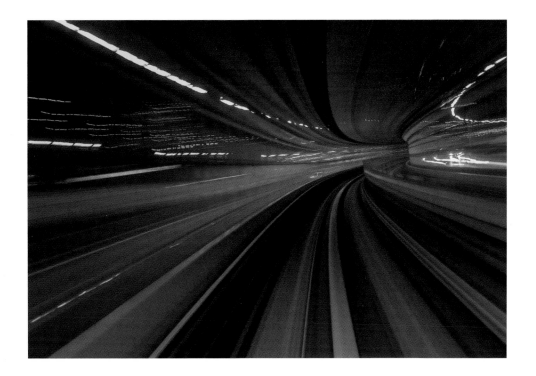

On the platforms of Shimotakaido Station, in the densely populated district of Setagaya

On board Yurikamome, the elevated train line without drivers

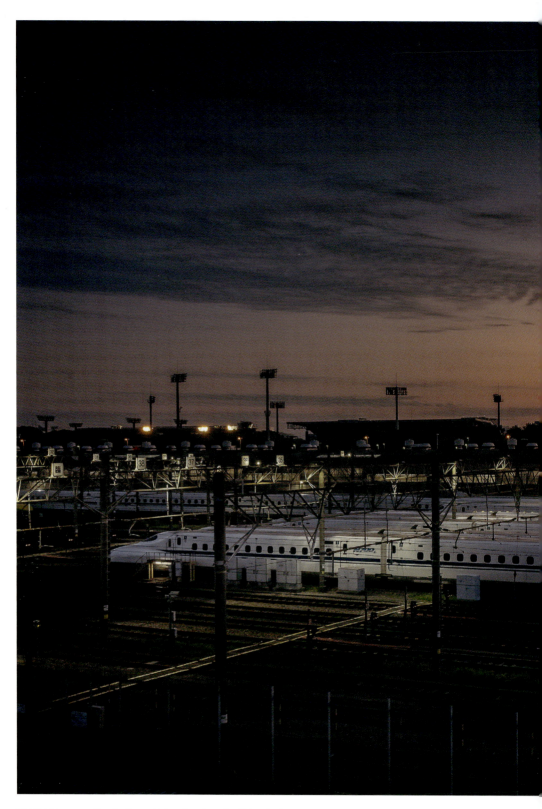

The Shinkansen, waiting for the next departure from the JR terminal

Train

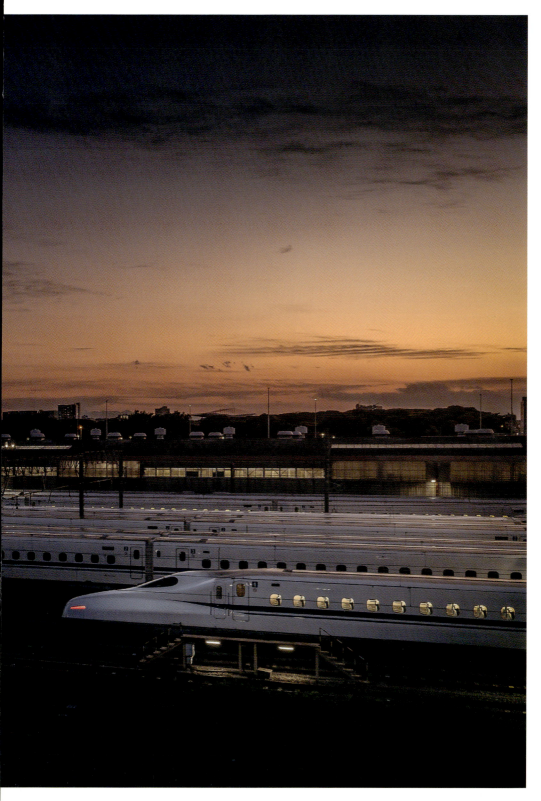

関東

(Kantō)

Kantō

Kawaguchi-ko

Located at the foot of Mount Fuji, only a few train stations away from central Tokyo, this place has become a must-see for hikers. Its name comes from the Fuji Five Lakes region, in reference to the five stretches of water that bathe the most famous mountain of Japan.

More famous than its four immediate neighbours (Yamanakako, Saiko, Shojiko, and Motosuko), Lake Kawaguchi offers many breathtaking views.

The ascent of Mount Fuji from Kawaguchi-ko is accessible to everyone and takes between 5 and 6 hours. In addition to this, it takes about an hour and a half to go around the crater and 3 hours to go down. A little advice: the descent is much more demanding on the knees than the ascent, so don't hesitate to bring walking sticks with you.

A change of scenery and a big breath of fresh air are guaranteed only 2 hours away from Tokyo.

Kamakura

Kamakura is a small seaside town located about 50km from Tokyo. Famous for its temples and its remarkable Buddha, the city is located on the Pacific coast and can be visited as part of an excursion to Enoshima, its neighbouring city that offers wonderful views of Mount Fuji.

Kamakura has a rich past marked by a high concentration of exceptional temples, but it especially prospered in the Japanese feudal period (1185-1333), during the expansion of Buddhism, popular in the country.

Very popular with surfers (mainly in the summer), the resort seduces with its many organic restaurants, its gentle way of life, and its heavenly setting. The many hikers who get lost in the surrounding hills to marvel at the sunrise will definitely agree.

Only one hour from Tokyo, Kamakura is very busy on weekends and during holidays. Good to know before planning your trip.

Nikko

Only 128km from Tokyo and easily accessible by public transportation, Nikko is a key place for Japanese Buddhism with an important historical heritage.

Despite a temporary decline in the 16th century due to the master at the time, Toyotomi Hideyoshi, who wanted to punish his monks for fighting him, the city flourished again later when Tokugawa Iemitsu built a set of delicately crafted religious buildings, decorated with rich colours and gold powder, inlaid with copper and silver. These structures were built in 1636 to pay homage to his grandfather, who was buried on this site. A 'baroque' architecture unique in Japan, it is classified as a World Heritage Site by Unesco.

The sacred bridge, the Rinnō-ji temple and the Tōshō-gū shrine are all must-sees.

Takao-san

Mount Takao (Takao-san) is only 55 minutes by train from Shinjuku (Tokyo's central station) and has some 7 marked hiking trails that go up to 600m high in the middle of nature.

At the top, you will find a panorama of mountains covered with lush vegetation and, if the sky is clear, you will have a magnificent view of Mount Fuji and the capital city in the distance.

With more than 1,200 species of plants, Mount Takao is notable for the extraordinary diversity of its flora but also for its wild animals and insects. A must-see for nature lovers.

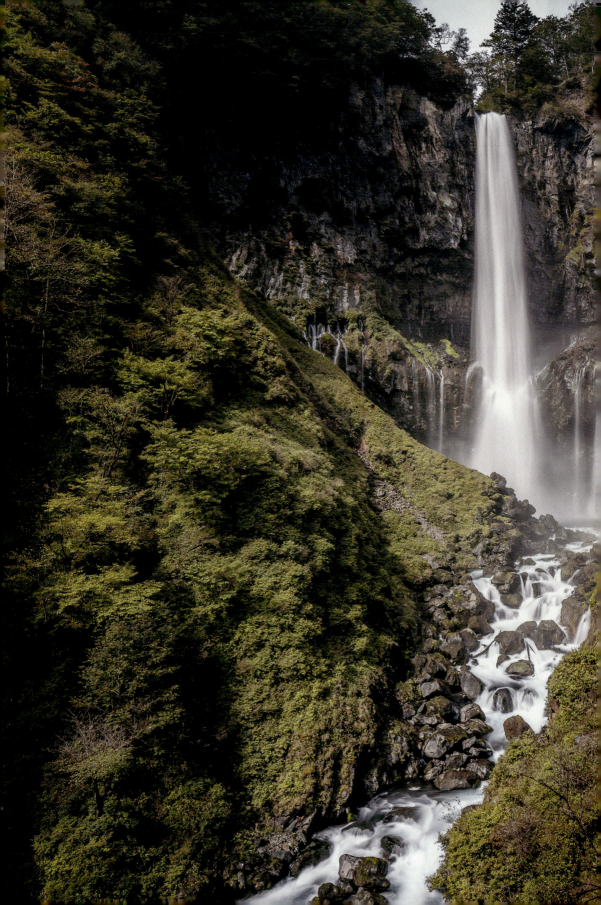

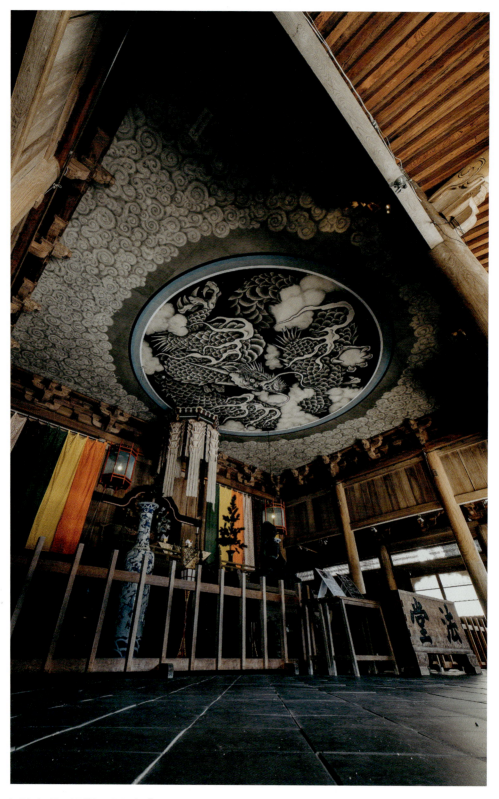

Inside the Kenchō-ji Temple, in the first gozan (group of five Zen temples) of Kamakura

The Great Buddha of Kamakura ▶

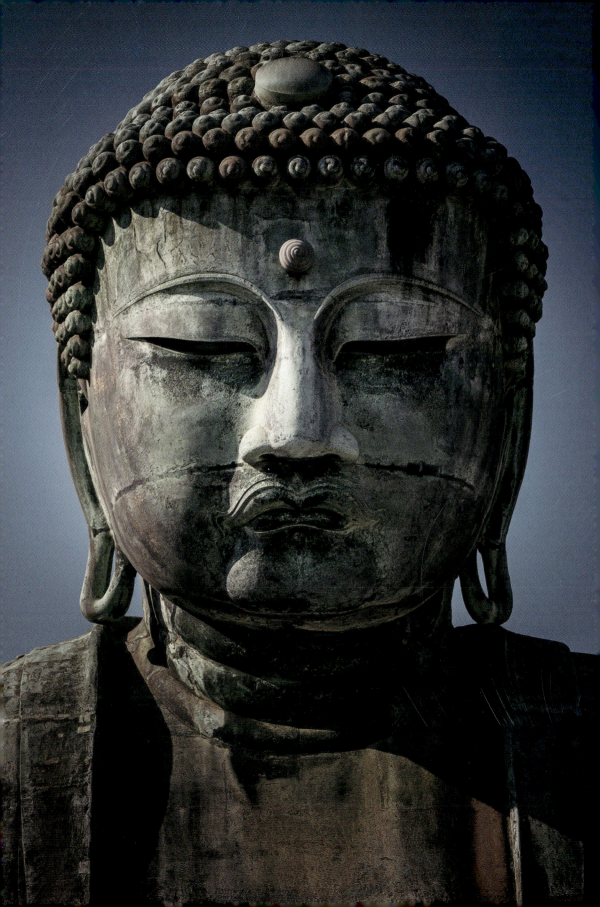

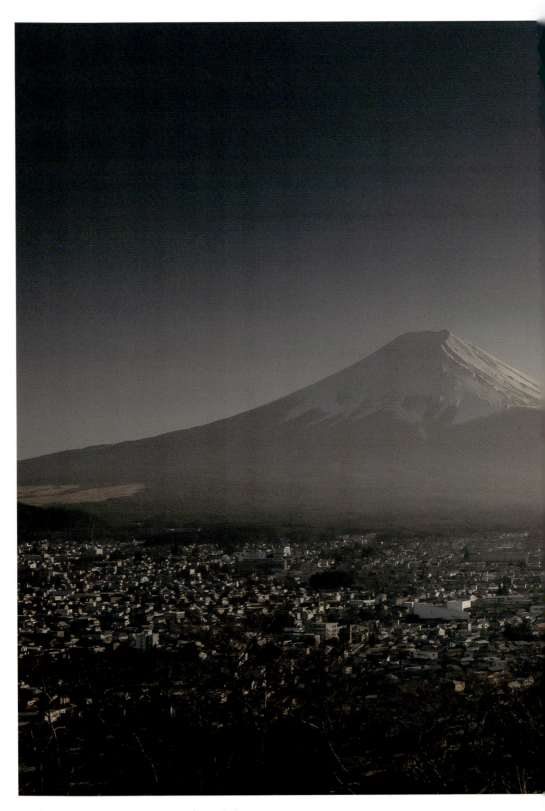
The Chureito Pagoda overlooking the area of Fujiyoshida

Kantō

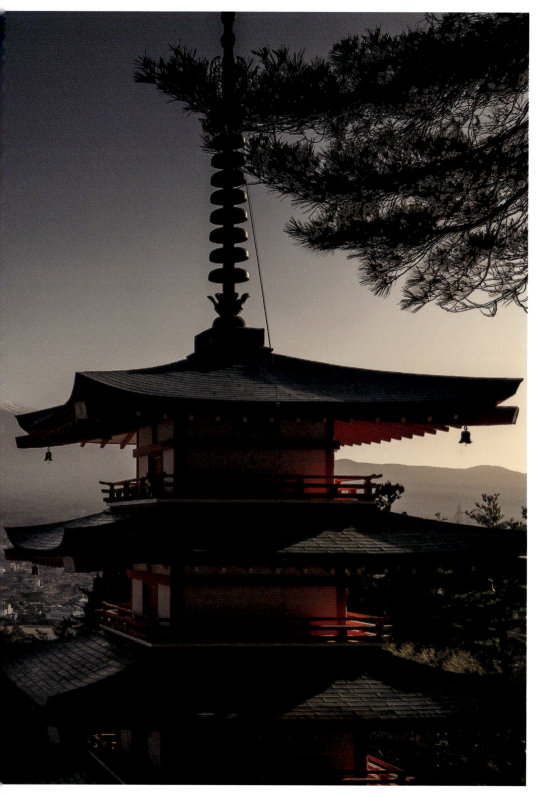

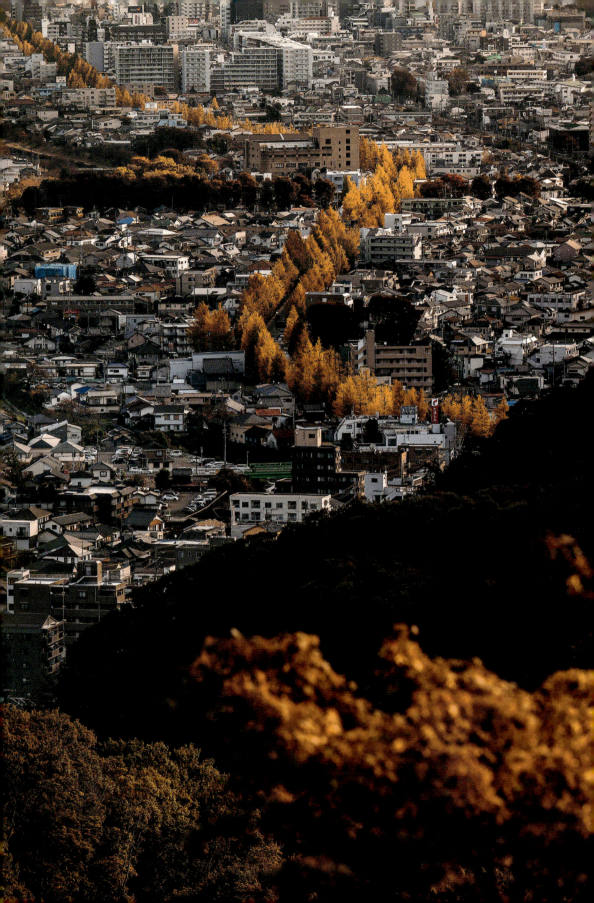

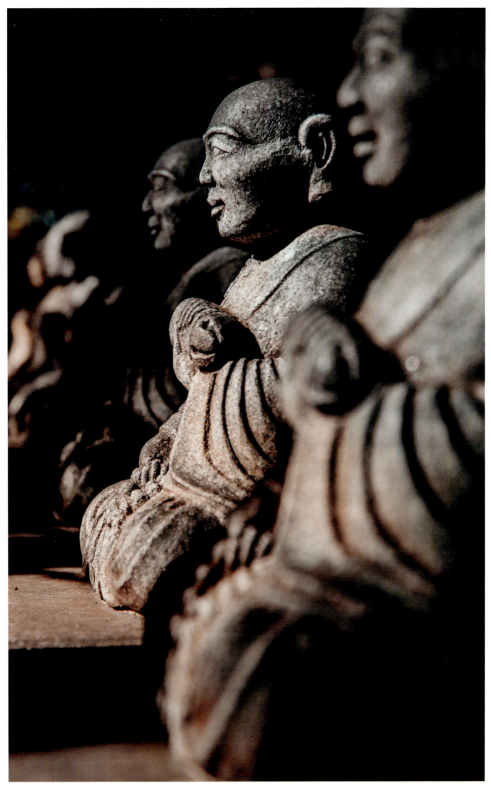

◀ A glimpse of autumn in the city, from Mount Takao

The statues of the Yakuou-in Buddhist temple in Hachiōji

京都

(Kyōto)

Kyoto

Tokyo might be the capital of Japan and especially the economic centre of the Japanese archipelago, but for Japanese people Kyoto remains the cultural capital of the Empire of the Rising Sun.

As it escaped the bombings of the Second World War and was spared from earthquakes and other natural disasters, this city of 1.4 million inhabitants with a rich historical heritage, is undoubtedly the Japanese megalopolis that best sublimates the customs and ancestral traditions of the country.

Founded in 794 as Heian-kyo, 'the capital of peace and tranquility', the city was built in the historical centre of Japan to become the base of the imperial court. Kyoto was built according to the plans of the great Chinese cities of the time, in a grid pattern. Ever larger and more powerful over the centuries, its name evolved to Miyako ('imperial city') and eventually Kyoto ('capital city'). The cradle of the Japanese emperors remained the capital of the Japanese empire until 1868, when the emperor moved to Edo (now Tokyo).

You can still find obvious traces of Kyoto's centuries of greatness, starting with its temples and shrines erected at every street corner, but not only...

Modern and old-fashioned

Bordered on the west, north, and east by hills and mountains where great Buddhist and Shinto centres are located, and bisected by the Uji River, the 40km long and 10km wide city welcomes a good part of its visitors through its central station, where the Shinkansen from Tokyo stops every 5 minutes. After a two-and-a-half-hour journey, tourists discover an ultramodern station, which looks like a shopping mall. Designed by the Japanese architect Koji Hara and completed in 1997, it proves that Kyoto (as many places in Japan) is an ancient city with its sights firmly set on the future.

Further proof that the old and the new often rub shoulders in the archipelago is the world's largest pagoda; built in 1644, its stands just a stone's throw away from the station and the centre of Kyoto. A symbol of the importance of the Toji temple (Kyō-ō-gokoku-ji) that it complements – every Japanese temple must have its pagoda! – this 55m-high wooden structure spread over four floors is considered the highest in the country. It holds a treasure composed of statues of four Buddhas and their disciples.

Not far from the city centre, about 15 minutes by bus east of the station, are the two most visited areas of Kyoto: Gion and Higashiyama. The first one is famous for its geishas and symbolises, in the eyes of the many Japanese, everything that is pleasant in life: sake, good food, women, and karaoke. Gion most certainly is the local 'place to be' where one lives by night and sleeps by day. Therefore, you will have to wait for the sunset to meet powdered maiko (geisha apprentices), ghosts of another era still present in the heart of the Japanese people. A little to the east, the Yasaka shrine, with its large vermilion torii (symbolic gate), opens a window on Higashiyama ('The Eastern Mountains'). This district, which constitutes the heart and lungs of the former capital city, is worth spending a whole day in. Its stunning mountainside temples and shrines are not to be missed: it's impossible not to be amazed by Chion-in Temple and its colossal gate; Shoren-in Temple and its tea pavilion; the Otani Mausoleum and its golden gate, and the Ryoze Kwan-on Shrine and its colossal 24m-high statue. The Higashiyama district is also famous for its small streets of another age, such as the Ishibe-Koji alley, which is lined with discreet inns and tea houses. A place that seems out of time and where it is not rare to meet Japanese women in kimono.

The fascinating Kiyomizu-dera Temple, another popular place to visit, features foundations that rest partly on a vertiginous wooden structure built on stilts, and boasts a huge terrace overlooking Kyoto. First built in 798 but destroyed (and then renovated) several times, the temple attracts many pilgrims. For more than 1,000 years, they have been climbing the slopes of the mountain to come and pray to the 11-headed goddess Kannon.

Temples and... an aquarium

To the northwest of the city, there are still more temples and shrines emblematic of Kyoto. The most famous of them all is undoubtedly Kinkaku-ji. Located near a pond where great blue herons come to hunt, the 'Temple of the Golden Pavilion' takes its name from its façade, covered in pure gold leaf. Restored after a fire in 1950, the two-storey monument, topped by a golden phoenix, is still as majestic as ever. It has never ceased to capture the attention of its thousands of daily visitors, amassed on the other side of the riverbank; it is without a doubt the most visited tourist site in the city, and maybe even in the whole of Japan. Because of this, visitors have to choose the right time to go there, either early in the morning or late in the afternoon.

A little further west, the Ryoan-ji Temple also attracts plenty of visitors: its dry garden, made of white sand and 15 stones, is considered as the supreme expression of Zen Buddhism. A place with strong symbolism, it invites introspection, leaving each visitor to examine its feeling when contemplating the mineral arrangement. The garden is preferably raked before 10 am, and the arrival of the hordes of tourists and schoolchildren...

Still further west is Ninna-ji, the first and most important temple of the imperial court. Dominated by a 40m, four-storey-high pagoda, the building is accessible through a colossal gate guarded by a pair of niō, two huge carved wooden statues designed to protect the temple.

Nearby Myoshin-ji is also worth the detour. Much more than a temple, it is actually a sprawling complex made of 47 different buildings. Only four of them can be visited though: Honbo, Taizō-in, Keishun-in and Daishin-in.

And if you decided to head east, you will find Nanzen-ji Temple and its Hojo Hall, which overlooks a beautiful Zen garden decorated with flowers, trees, and shrubs.

Finally, if you are travelling with children, you absolutely must visit the Kyoto Aquarium, inaugurated in 2013 and located west of the central station. A unique place specialised in the fauna of the rivers and other freshwater spots of the archipelago, it is known for its collection of giant salamanders (from Japan and China) which can reach 1,20m in length.

A rich gastronomy

But visiting Kyoto is not only about trekking from temple to temple. To fully enjoy the city, you must also get lost in its small streets, where traditional wooden houses are still standing and buildings rarely exceed five floors. Historical pagodas are the only towers allowed, except for the city centre's Kyoto Tower, which offers a magnificent panorama of the ancient capital.

Kyoto people are generally friendly and hospitable and are always willing to help at the slightest opportunity. With 37 universities and many schools, the large number of students and children brings life to the city.

In this country full of restaurants, Kyoto also occupies a place of choice in Japanese gastronomy. Sashimi, sushi, yakitori, tempura, okonomiyaki, yaki-udon, soba... The city admirably represents the richness of Kansai, a region which although a little poor in seafood due to its geography is renowned for its high-quality products.

Some of the most famous temples, some of the most interesting religious sanctuaries, some of the most beautiful natural parks, some of the most typical alleys, and some of the richest gastronomy in the country: Kyoto, a true 'museum city', does not lack attractions to seduce all those who really want to immerse themselves in the Japanese culture. An immersion all the easier as the city, as safe as Tokyo, offers a very complete public transport service as well as many cheap hotels. What more could you ask for?

The Yasaka pagoda, one of the oldest buildings in Tokyo

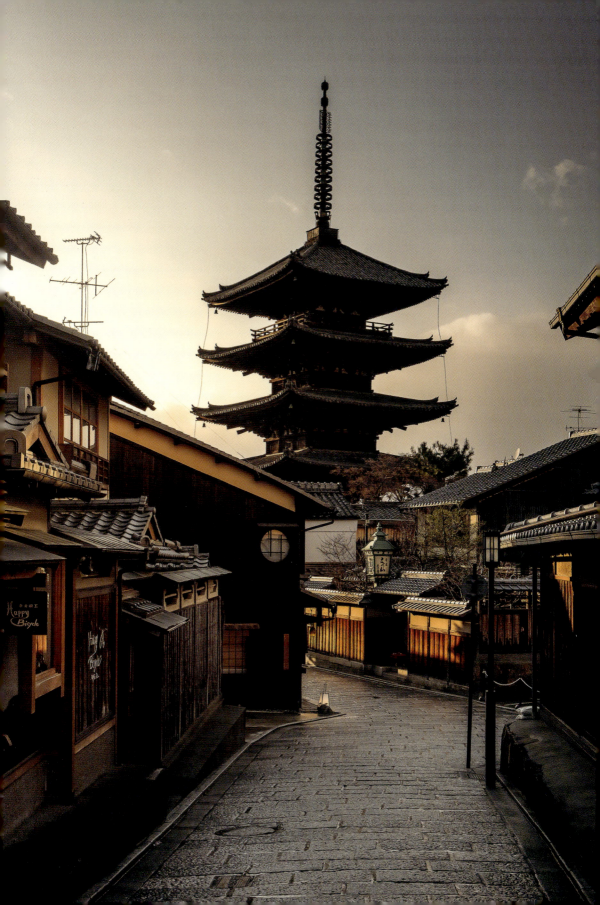

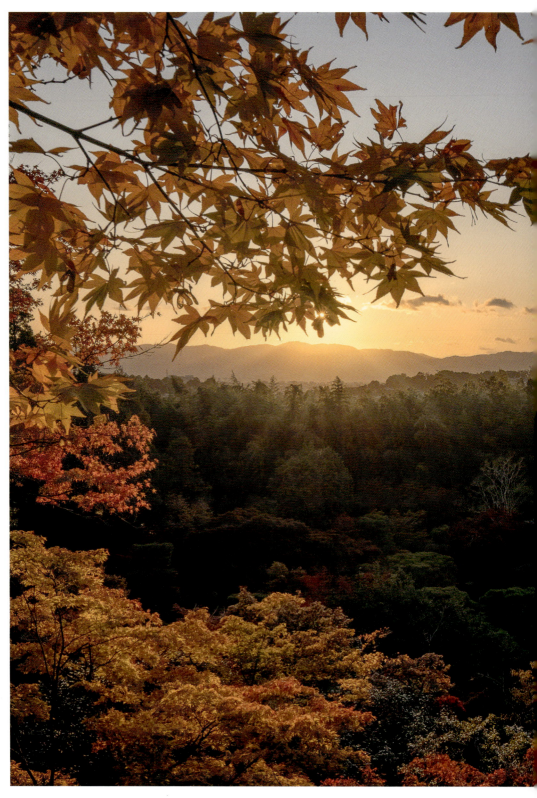

A panoramic autumnal view of Ginkaku-Ji, temple of the Silver Pavilion

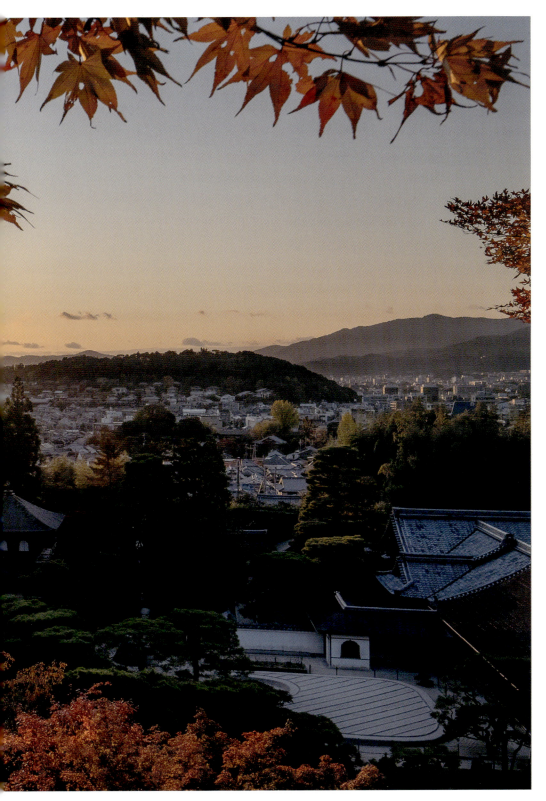

Kyoto

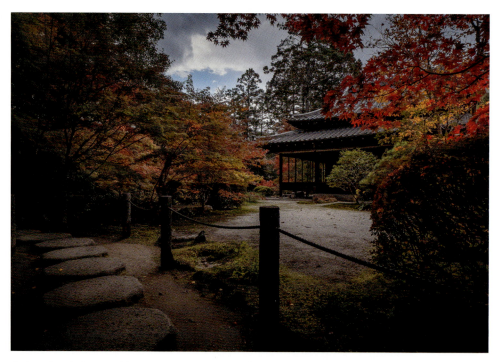

Tenju-an Temple, in eastern Kyoto

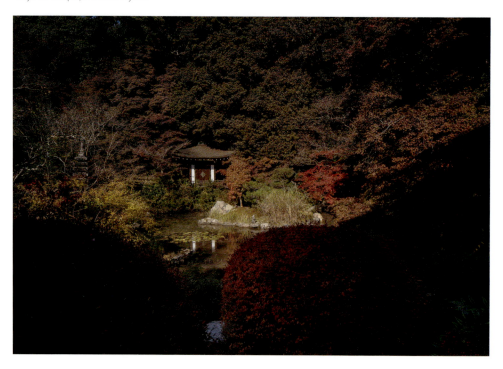

The garden of Bishamon-dō Temple

Ginkaku-ji, the Silver Pavilion, ▶
is reflected in its garden

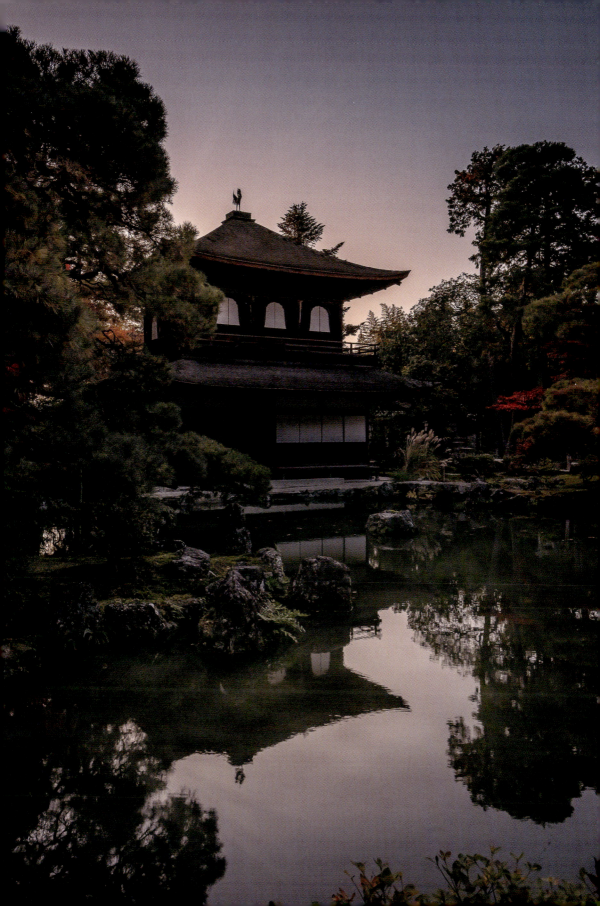

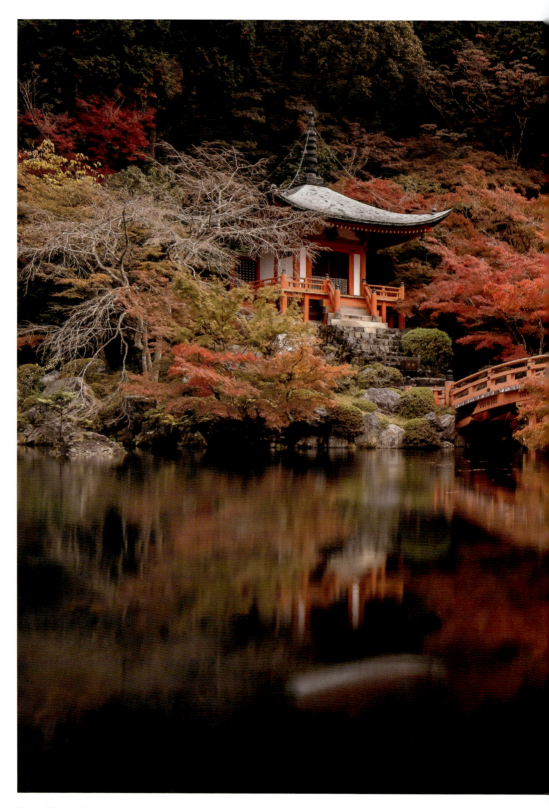

Daigo-ji lined with Japanese maples

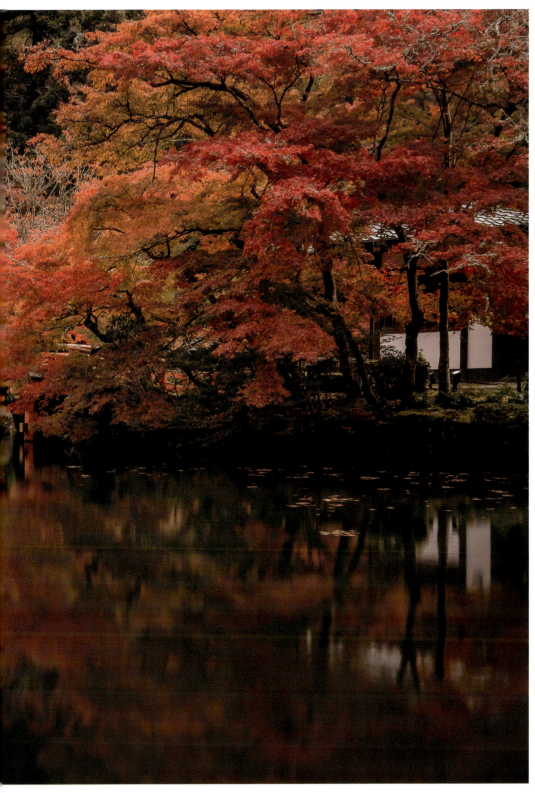

Lanterns at the entrance of Kifune-jinja Shrine

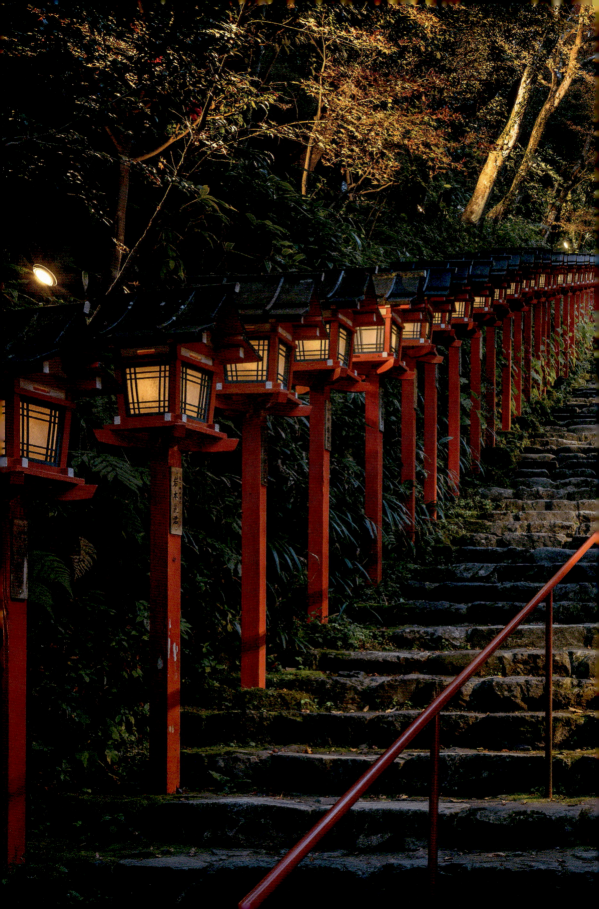

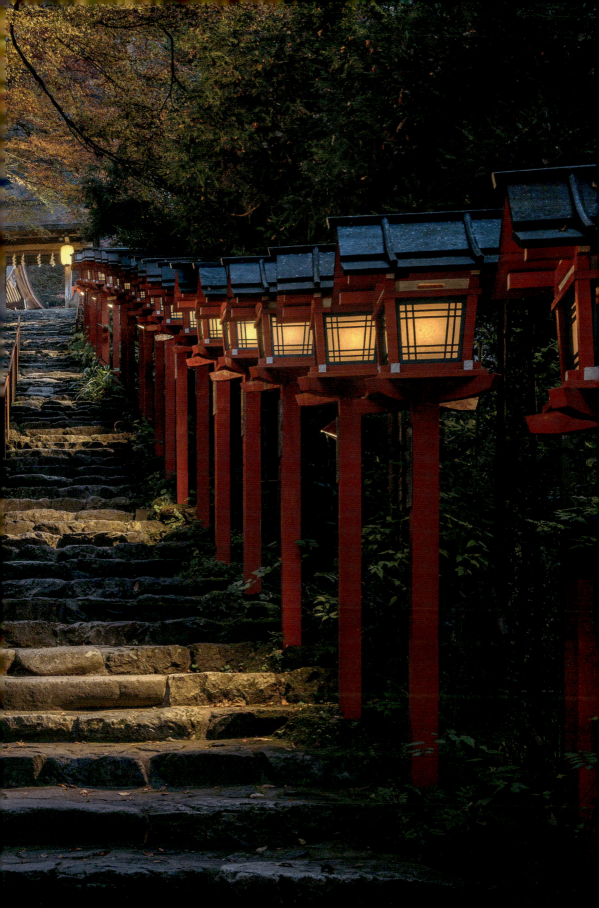

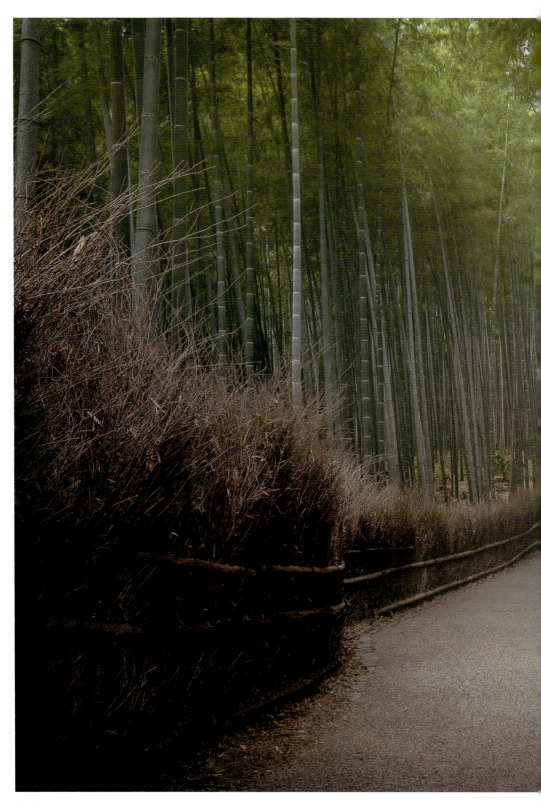

The Arashiyama Bamboo Grove

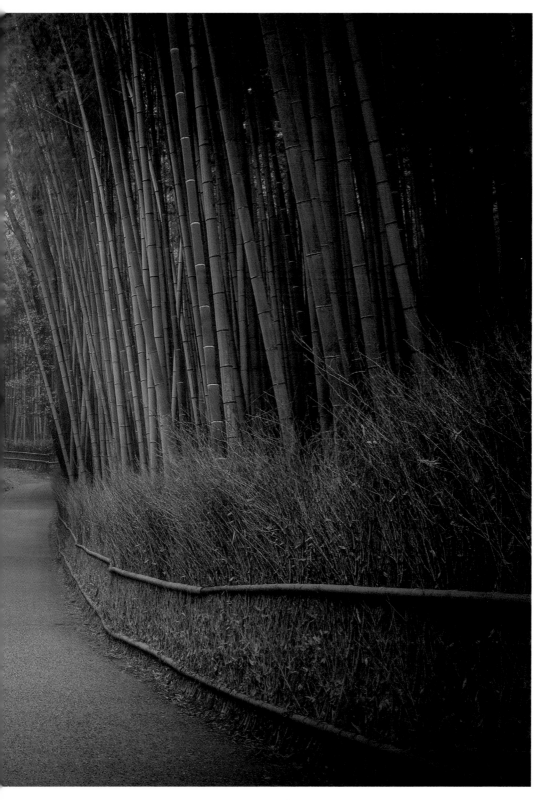

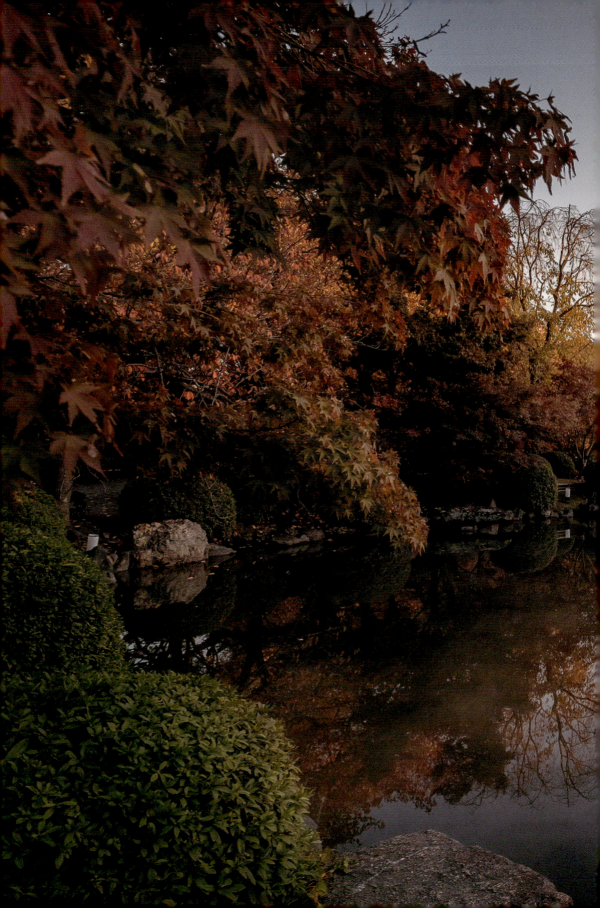

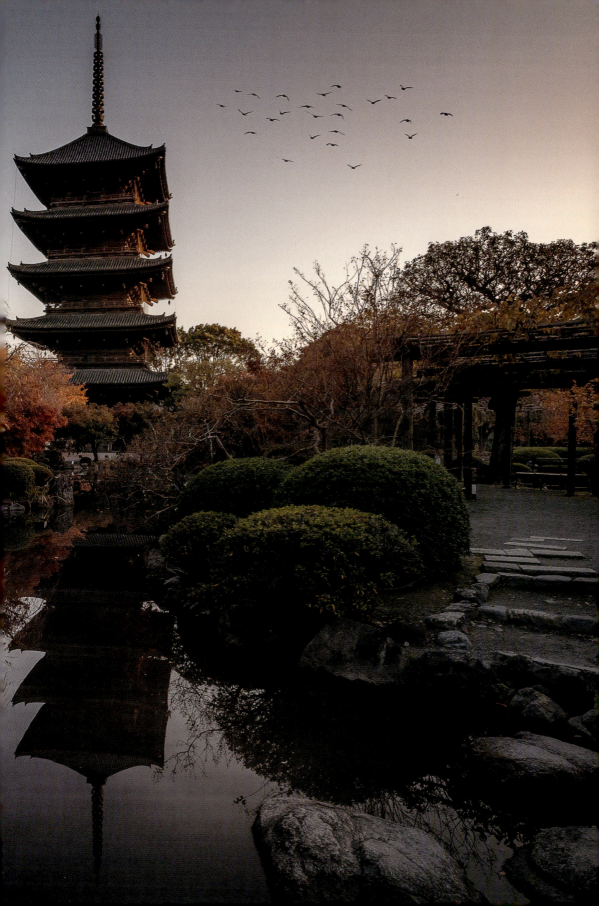

Kyoto

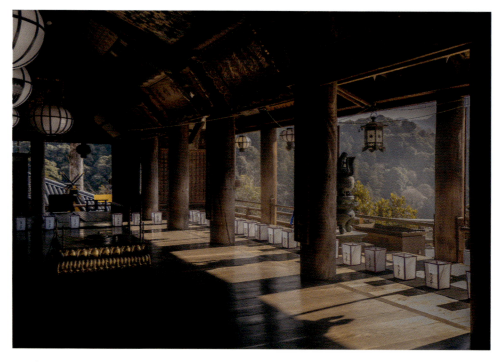

Hasedera Temple in Nara

◄ The To-ji Temple and the tallest pagoda in Japan

A woman selling 'Senbei' for the Nara deer, ►
sacred animals that have become national treasures

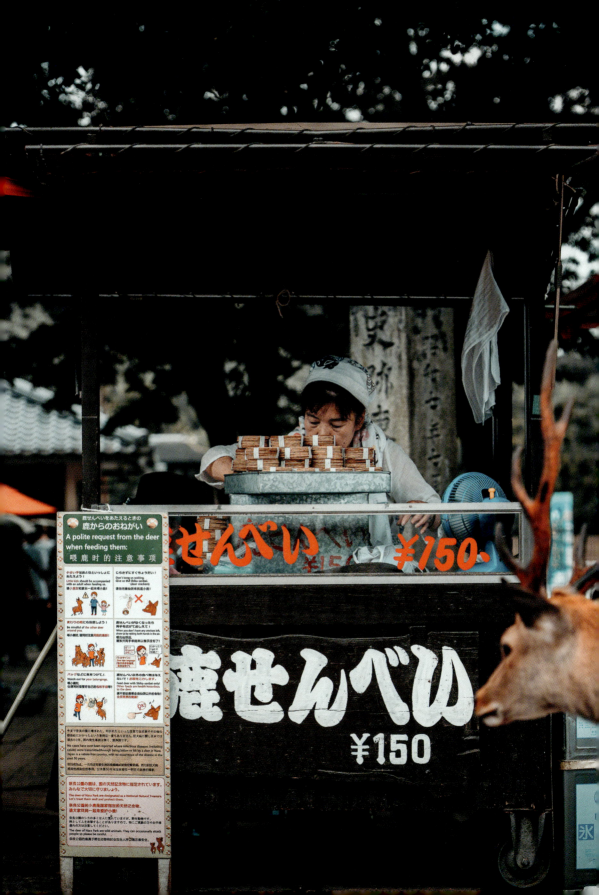

宗教

(Shūkyō)

Religion

In Japan, spirits are everywhere!

On the island, these spirits are called kami and the belief in this multitude of deities forms the basis of Shintoism or Shinto, the very first Japanese religion.

In a few words, Shinto principles focus on the respect of nature and everything that surrounds man, whether it is a flower, a stone, or an animal. For the Japanese, the sun, the mountains, the sea, wind, or even fire are thus sacred... because they are all inhabited by spirits.

Unlike Christianity or Islam, Shinto does not rely on any holy book, which explains, in part, the mystery that still hangs over this religion.

Displays of Shinto fervour, the shrines, composed of *Honden* (the main building) and *Haiden* (the place where the faithful come to pray), have invaded the whole archipelago over the centuries. These places are often full of mysticism, and it is advised to respect some ancestral rules when visiting them.

Rites to respect

It is good to bow to greet the gods when passing through a shrine's entrance door, or *tori*, which separates the profane world from the sacred world. And a little further on, in front of the main pool, there is also an ablution basin (*chozuya*), for worshippers to wash their hands and mouths.

In the temple enclosure, other rituals may also surprise you. You will discover for example small pieces of paper (*omikuji*) that are occasionally drawn at random and on which a prediction is written. A souvenir? Not necessarily! Indeed, if this prediction turns out to be unfortunate, you will have to tie the paper to a wooden support to ward off the bad luck. This, in some places, gives birth to *gohei*, strips of folded paper hung all over the shrine.

A mixture of beliefs

Although it remains rather enigmatic for many Westerners, Shinto (which reveals itself a little if one takes the trouble to read some of the numerous books which refer to it) is not a religion to be taken lightly. On the contrary! In Japan, it is indeed one of the founding pillars of the nation. Almost in the same way as... Buddhism.

Intriguingly, Japanese people easily mix Shinto and Buddhism, to the point that many of them have difficulties stating what their own religion is. Over the years, the two national religions have become entwined and are now culturally inseparable, with most Japanese people taking part in both Shinto and Buddhist rituals and festivals.

As is the case in many other cultures around the world, Buddhism has become well established in Japanese society since it appeared in the 6th century AD. Over time, it even acquired a Japanese name: *Shingon*.

Intrigued by the Japanese version of Buddhism? Then explore some of the numerous Buddhist temples that have been built on the archipelago and resemble Shinto shrines in many ways. They are composed of an enclosure (*kairo*), the main gate that marks the entrance, the main building (*kondo*), and an incense burner, with its characteristic smell and its wisps of smoke that call for meditation, even for a layperson.

The majority of Buddhist temples have an adjoining pagoda as well as a shoro and a kodo – buildings reserved for the prayer of the monks and the reading of the sacred scriptures.

The heart and soul of the Japanese people are slightly torn between Shintoism and Buddhism. However, one thing is sure: it is also this unusual mixture of religions that certainly explains their Zen attitude and the respectful wisdom they show towards each other.

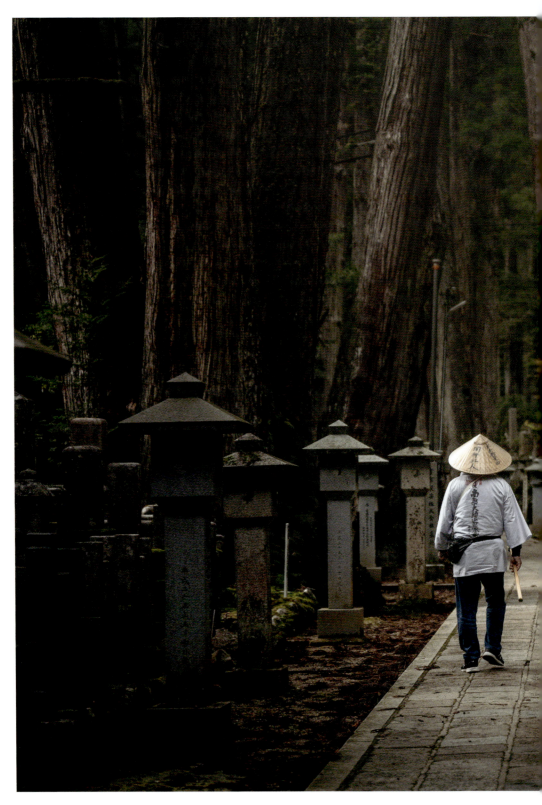

Pilgrim crossing the Okunoin Cemetery in Koyasan

Religion

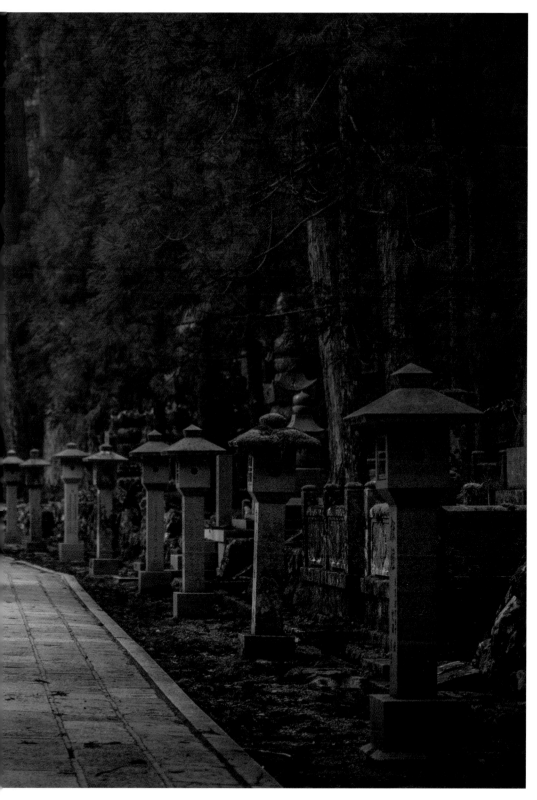

Religion

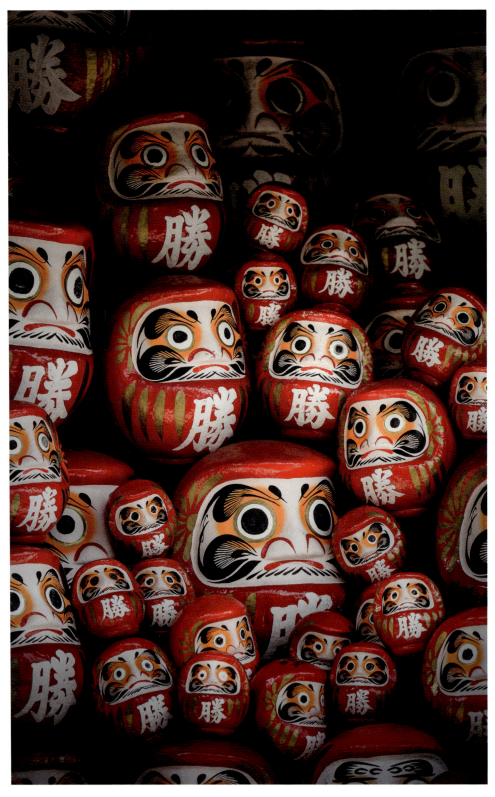

Daruma: wishing dolls

A Buddhist monk at Kenchō-ji Temple ▶

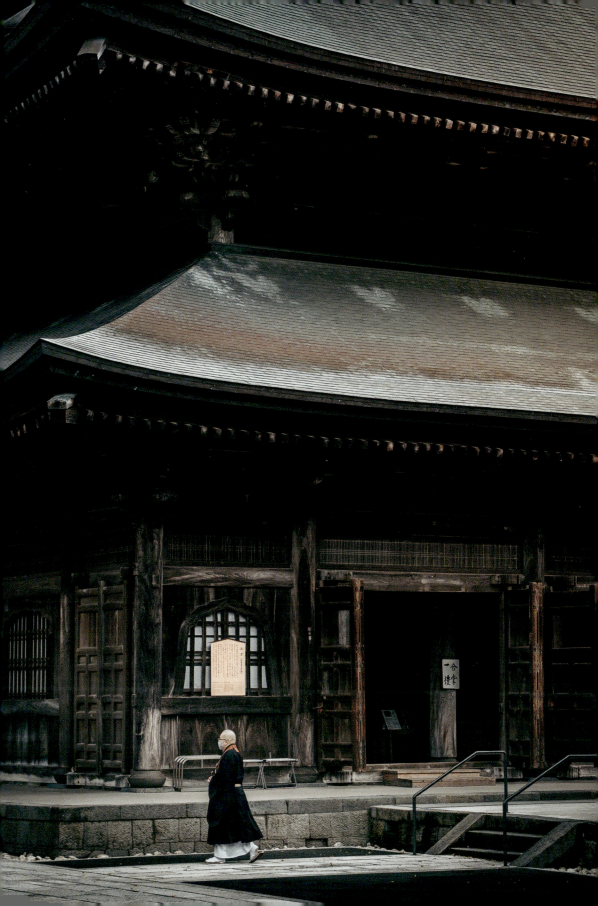

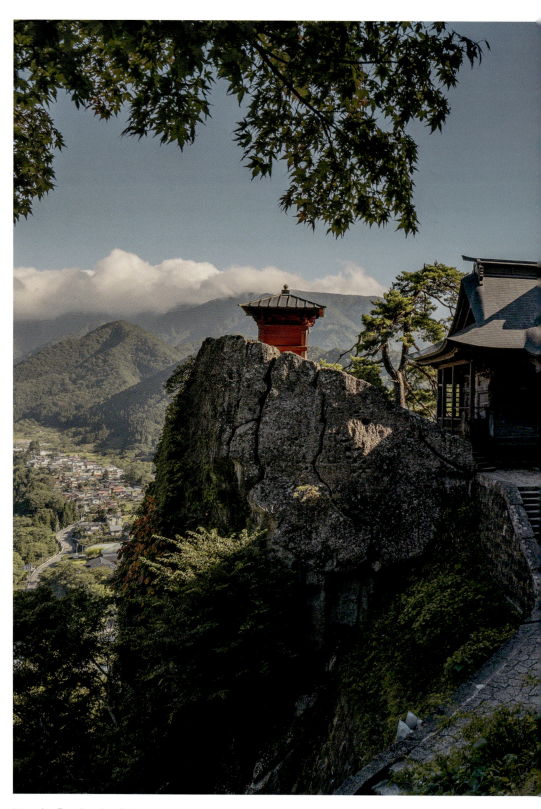

Yama-dera Temple, or literally 'Mountain Temple', in Yamagata Prefecture

Religion

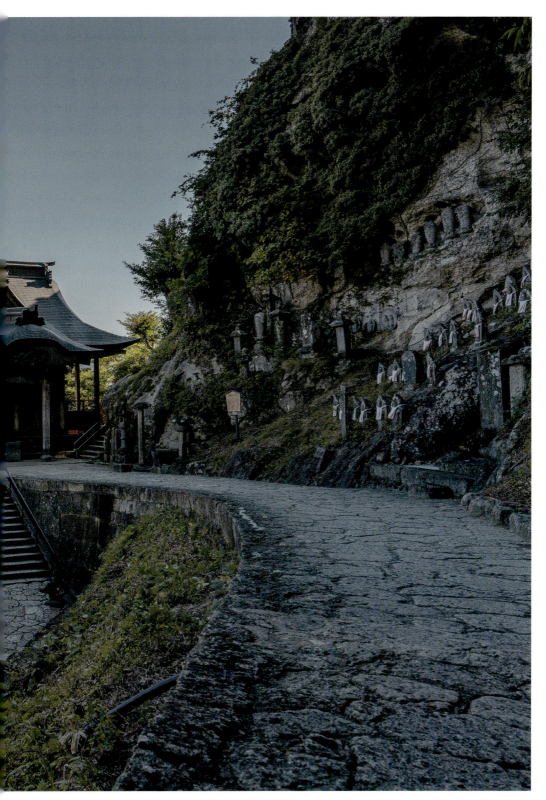

規則

(Kisoku)

Rules

In Japan, one thing will become obvious as soon as you arrive at the airport: everyone works to serve the collective wellbeing while preserving the existing harmony. A matter of course for all the inhabitants of the island you will meet, this is the main rule of life in Japanese society.

Historically, this code of conduct has its origins in Bushido, which gathered moral principles that the Japanese samurais scrupulously followed and to which the Japanese remain very attached. A true reference, Bushido guides the behaviour of the Nipponese, even in less martial everyday situations.

More than elsewhere, the social codes adopted by the Japanese have been chosen in order not to offend or disappoint others by inappropriate behaviour. For example, in public transportation, although all passengers have their eyes riveted on their phone, everyone remembers to mute it in order not to disturb other commuters.

Though it may be disconcerting at first, it's nice to walk around the most densely populated cities in the world without ever hearing any unwanted noise, shouts, or telephone chatter.

You will certainly appreciate these polite gestures, which show great respect but also great modesty.

Land of subtleties

Clearly, the Japanese are experts in the art of courtesy. And where, for Westerners, every greeting resembles another, the descendants of the samurai can recognise (or express) different marks of respect according to the inclination of the head and the body.

A land of subtleties, Japan even distinguishes between being and appearing. Indeed, *honne* and *tatemae* are two Japanese words used to describe the contrast that can exist between the true feelings and desires of a person (*honne*), and the conduct as well as the opinions that that person shows in public (*tatemae*).

When it comes to being respectful, the Japanese language even offers a dozen different ways to say 'thank you'. In the Land of the Rising Sun, there is no shortage of polite expressions!

Finally, in the same vein, let's note that the Japanese give each other gifts all the time. Once again, this is a habit well anchored in society. And any occasion is good, whether it is when you visit someone or when you come back from a trip. Not respecting this custom (or forgetting to reciprocate with a gift) is akin to neglecting your duty. Fortunately for the Japanese, there is no lack of gift items on the island. The inhabitants gather every day in thousands of shopping malls, notably intended to maintain the social link.

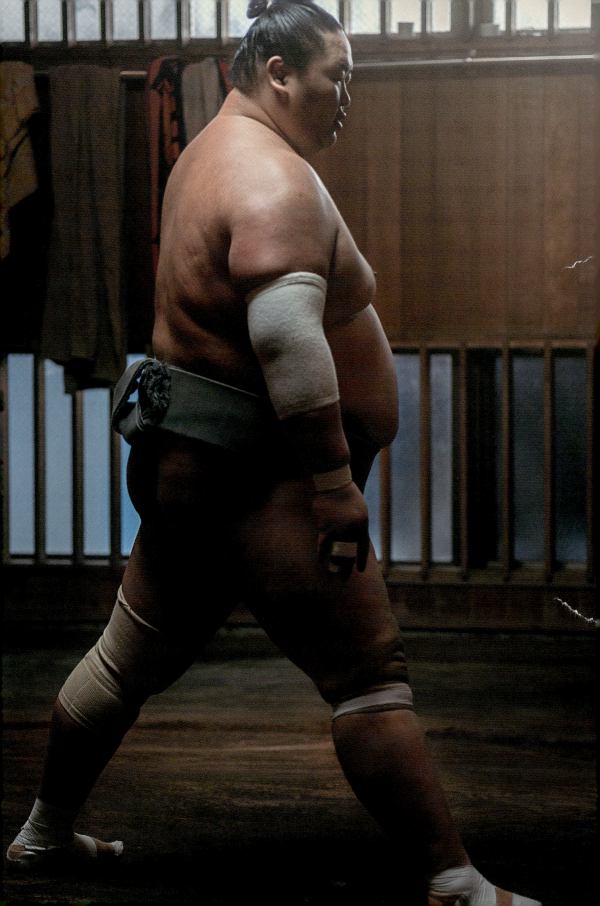

Rules

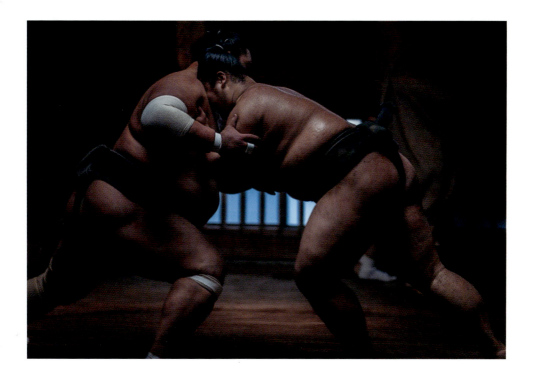

◀ A Sumo wearing his customary outfit

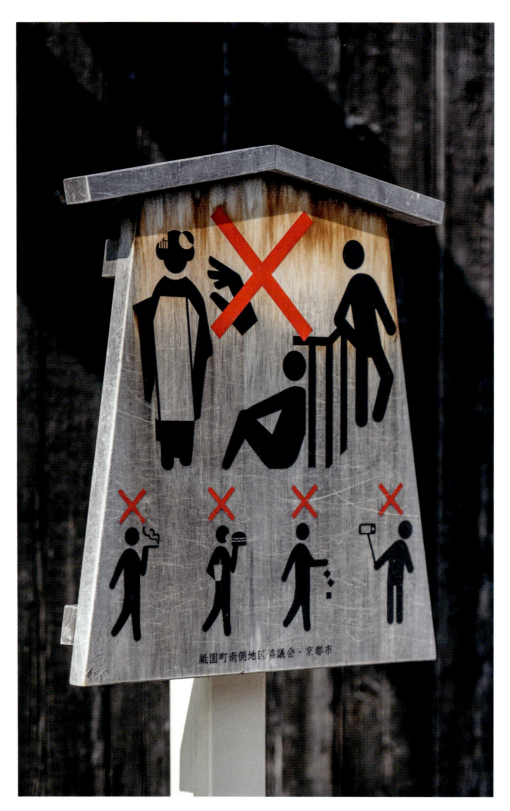

Everything is codified for a better social life

Rules

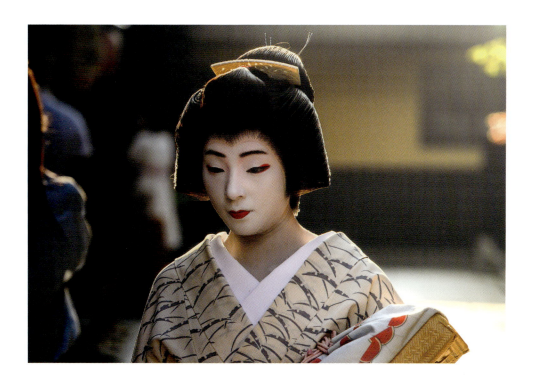

The grace and elegance of a *geisha*

(Ōsaka-shi)

Osaka

Popular, friendly, and a gourmet's paradise, Osaka is one of those Japanese cities where the climate, the atmosphere, and the gentle way of life make you feel like you have been transported to the South of France or Tuscany.

Well served by its large Kansai International Airport (an incredible feat of engineering, it is located on its own artificial island), Japan's second-largest economic city also maintains a cosmopolitan identity that has stuck to it since the 1970 world fair.

Its port, which is one of the largest trade hubs in Asia, makes Osaka the economic capital of Kansai. From the towers of Umeda to the neon maze of Dōtonbori, the city is in a perpetual state of flux and full of surprises – just like one of its most famous sons, Tadao Ando.

The award-winning Japanese architect is as atypical as the city in which he was born, and is recognised worldwide for his monumental, uncluttered, all-concrete buildings – one of which was commissioned by UNESCO.

In both Osaka and Tokyo, take the time to discover Tadao Ando's buildings: they embody the resolutely modernist style of a constantly evolving Japan, as shown by the Suntory Museum of Osaka, built in 1994.

Also worth seeing is the Tower of the Sun, a building designed by the Japanese artist Tarō Okamoto. Considered the symbol of Expo 70, it is located in the Expo Commemoration Park in Suita.

Finally, foodies cannot leave Osaka without trying some of its specialties such as takoyaki or okonomiyaki. Guaranteed to be a tasty experience, Osaka deserves its nickname of 'the Empire's kitchen'!

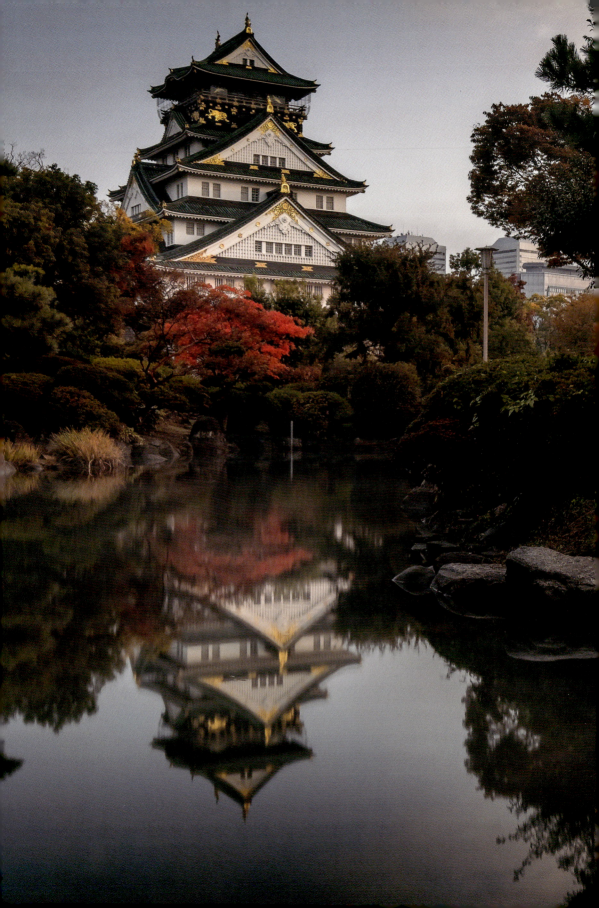

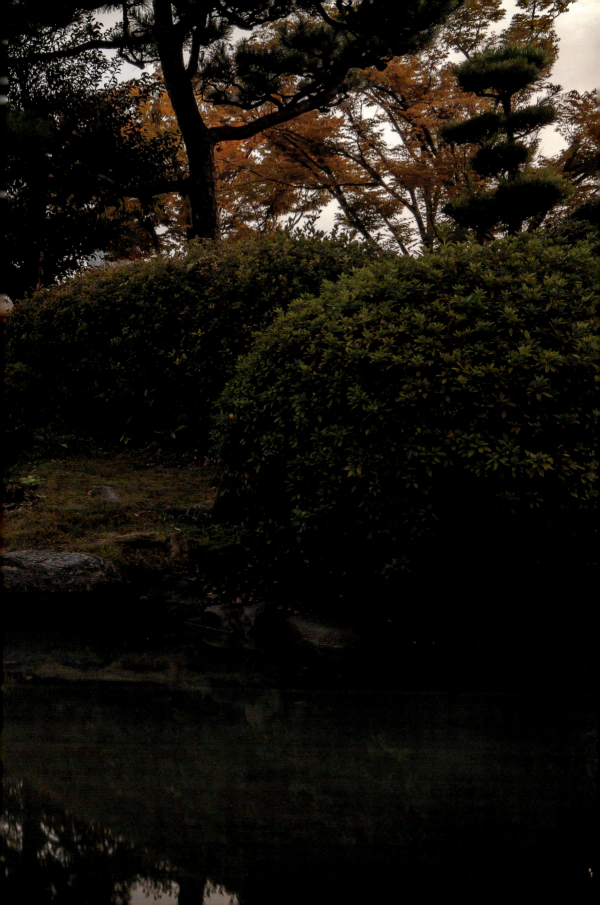

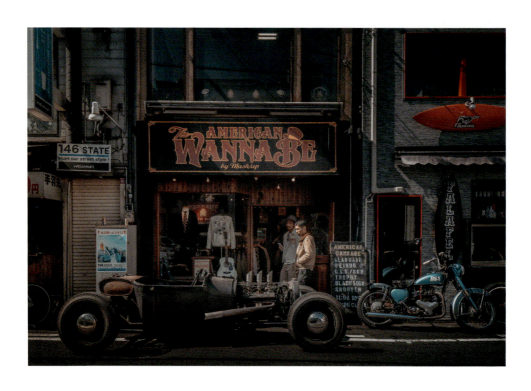

Hipster atmosphere in Shinsaibashi district

Osaka

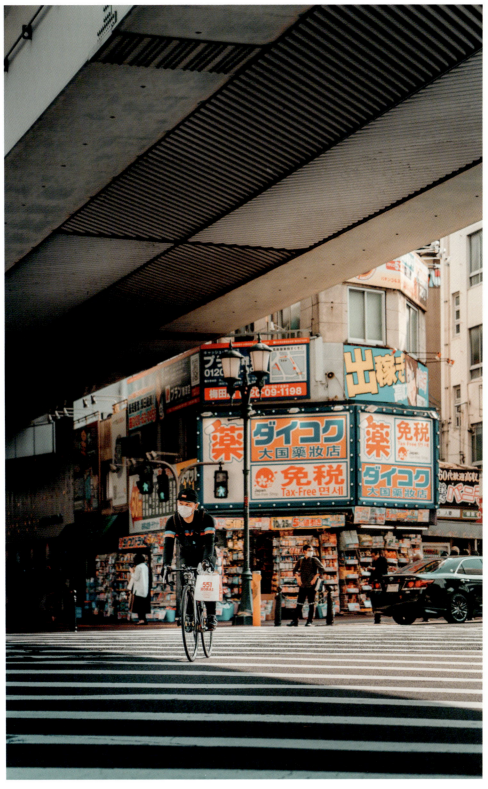

A cyclist in a street of Namba, large district of the city

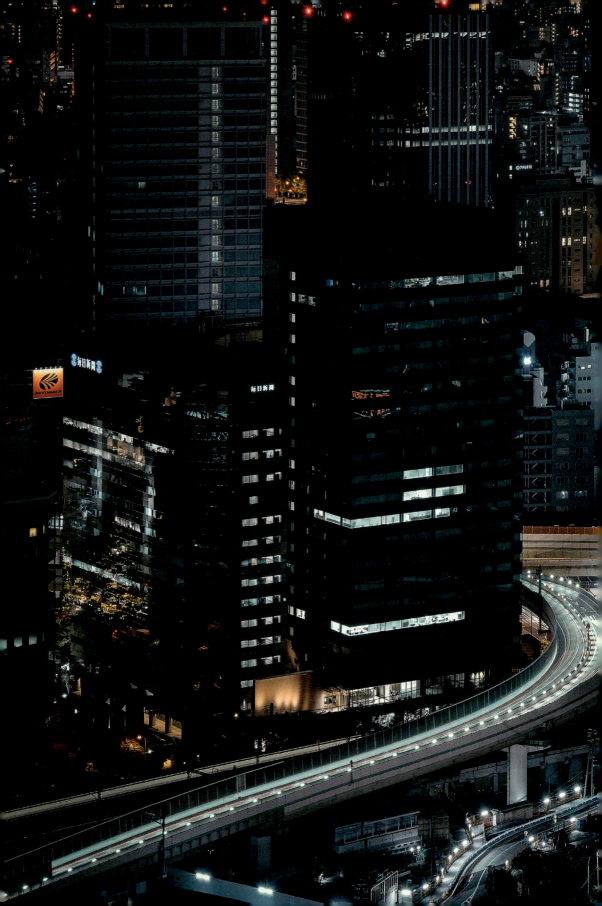

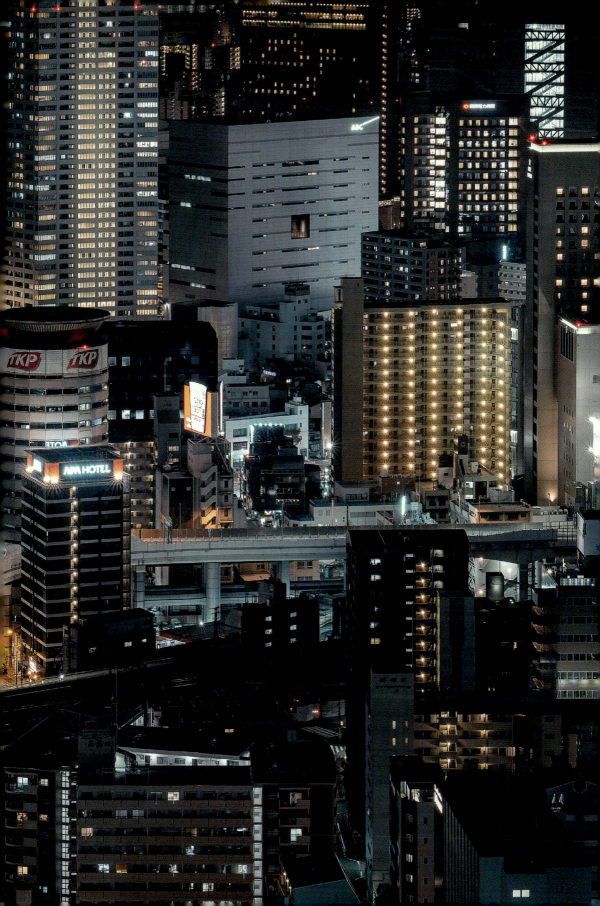

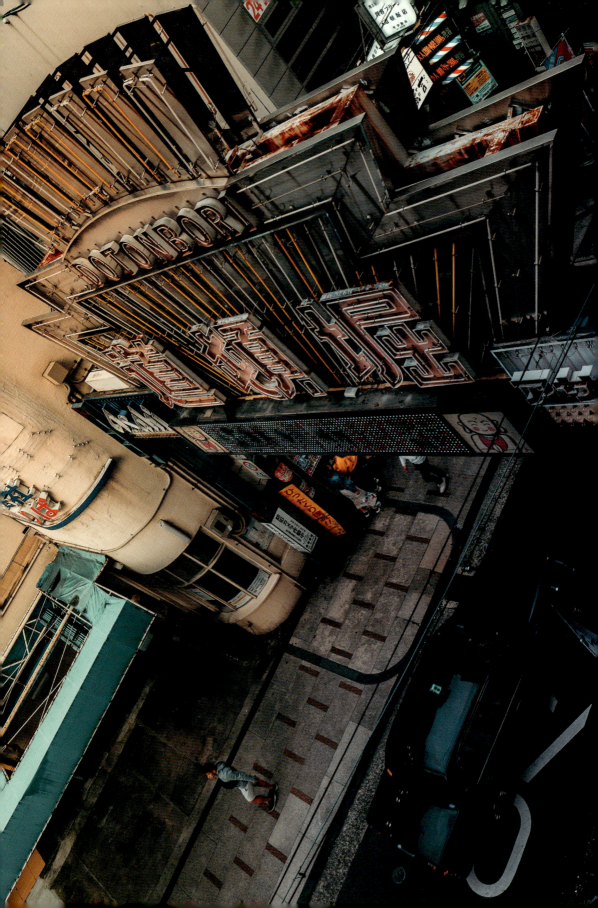

Osaka

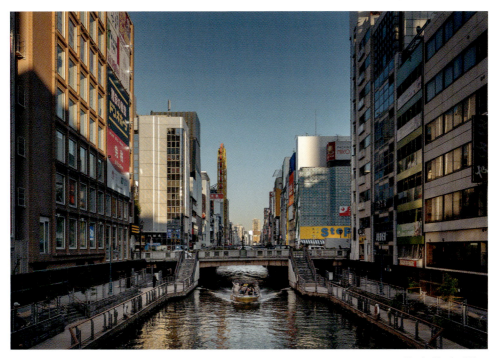

On the Tombori River

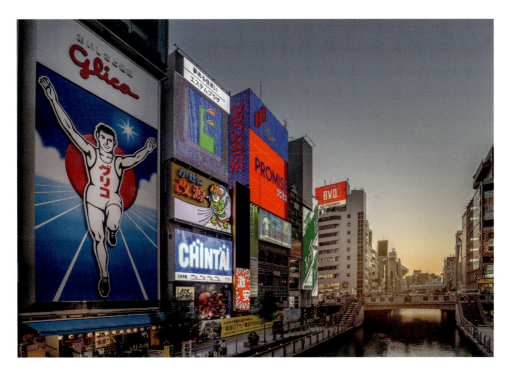

◂ Arriving in Dōtonbori, famous long street in Osaka

The Glico Running Man, Osaka's famous landmark

(Shokuji)

Gastronomy

Anyone visiting Japan cannot overlook its gastronomy. Ingredients, flavours, cooking methods, influences... Japanese cuisine is one of the most renowned in the world.

Rice is key to the local cuisine, of course, while the following saying perfectly summarises the daily menus of the archipelago: 'One soup, three plates'. Indeed, a Japanese meal generally comprises a miso soup and three side dishes with vegetables, fish or meat. Sugar, salt, vinegar, and soy are also common ingredients. Famously, the Japanese always take great care in the presentation of their dishes by combining shapes and colours in small but perfectly formed portions.

These delicate and well-balanced meals are eaten with chopsticks and come in an extremely wide price range.

But contrary to popular belief, it is possible to eat well in Japan for a reasonable price. How? By going to restaurants generally dedicated to one type of dish, such as, for example, skewers called satay, tempura (of scampi, poultry, or vegetables) as well as sushi of all kinds or ramen soups.

Of course, since the Japanese are also fond of great cuisine, there are many high-class establishments where a chef (sometimes starred) will prepare Kobe beef right in front of you. A treat for the taste buds but also for the eyes as it is a pleasure to see your plate being prepared by an artisan with incredible finesse and dexterity.

For those who don't dare to try Japanese cuisine, don't panic: there is no shortage of world cuisine and fast-food restaurants in the big cities.

However, in a country where the Buddhist religion had banned the consumption of meat for a long time and where it was not until the 19th century that eating habits changed slightly, the art of eating is still governed by immutable rules of politeness and good manners. Just as one must always finish one's meal by eating rice, or refill one's neighbour's glass if it is empty, one must not say anything if someone noisily sucks his noodles or eats his sushi with his fingers.

Soba or *udon* on the go in the alleys of Omoide Yokochō in Shinjuku

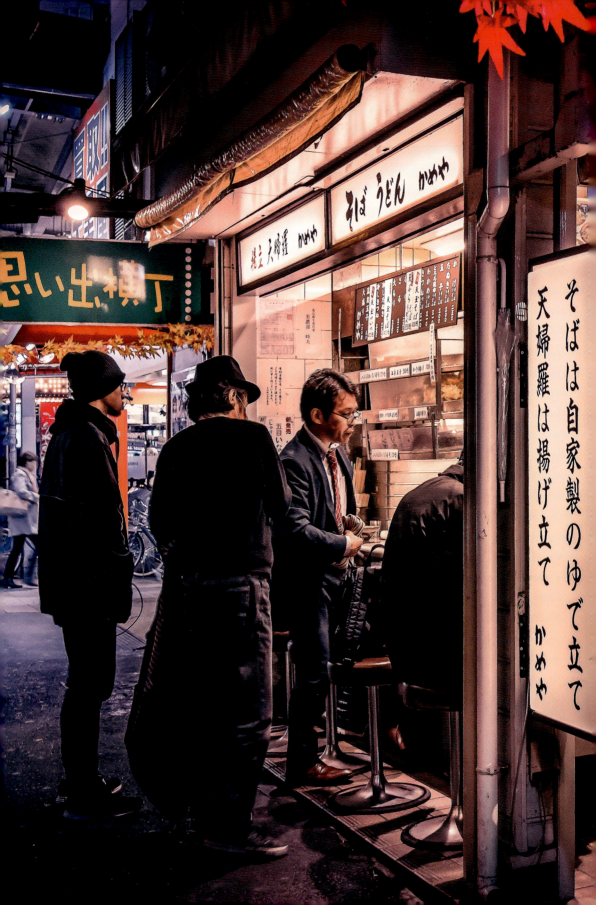

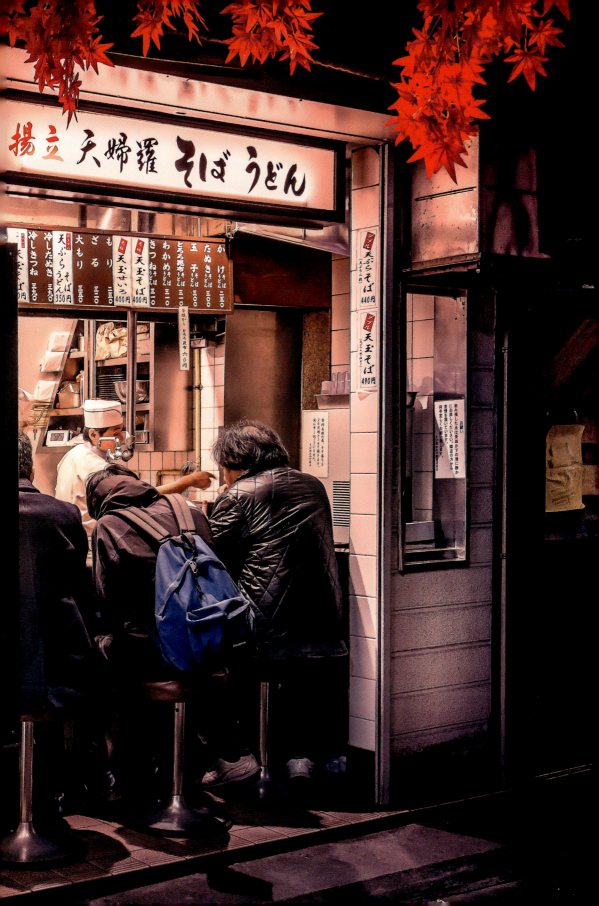

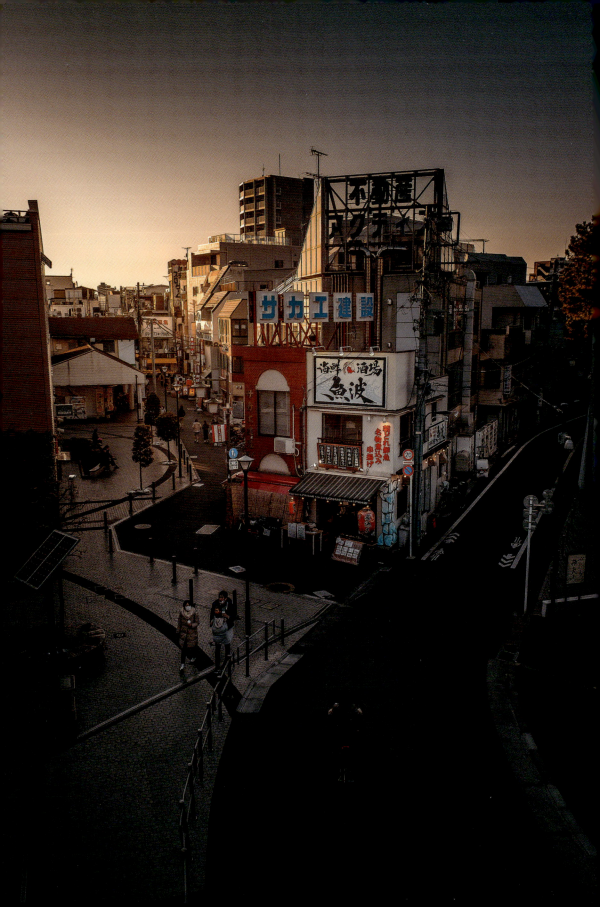

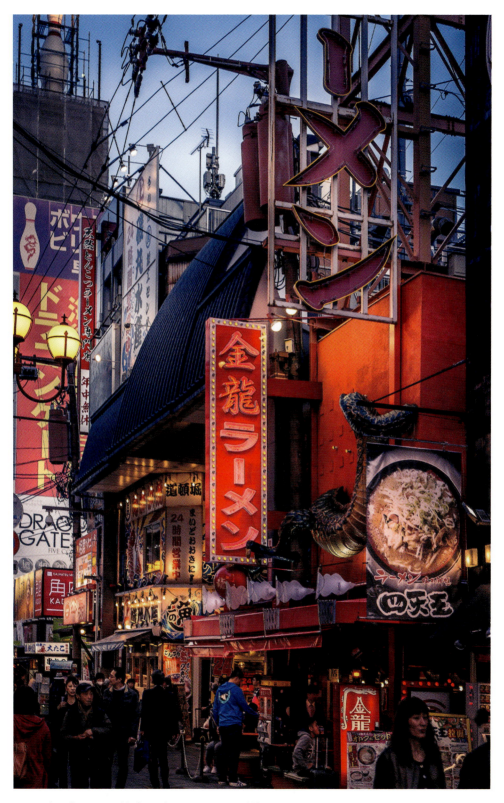

Izakaya for a successful afterwork

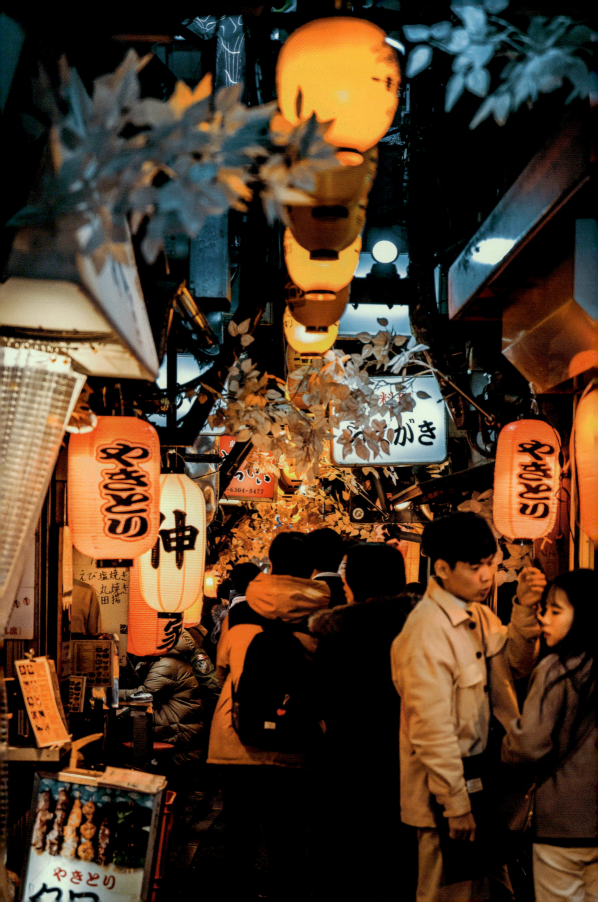

Gastronomy

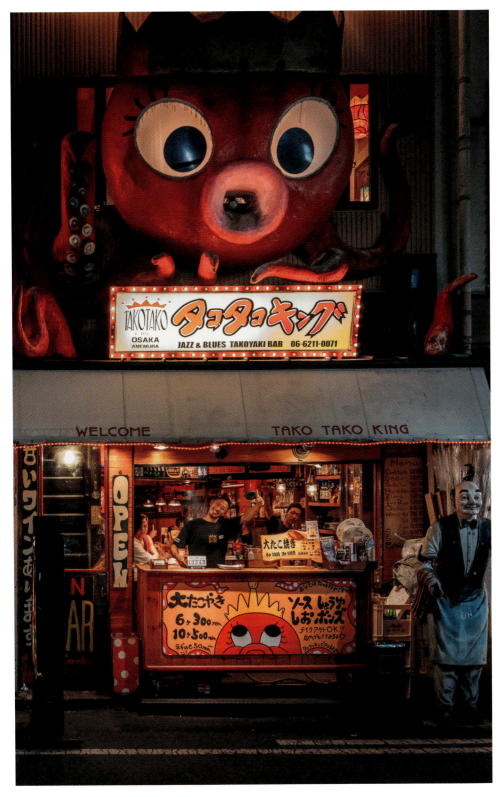

An alleyway of Omoide Yokochō, a series of alleys where you can enjoy typical food

The *takoyaki* king, literally 'grilled octopus' (balls of dough containing pieces of octopus)

横浜

(Yokohama)

Yokohama

The second most populated city in Japan, Yokohama is hardly distinguishable from its neighbour Tokyo, to which it is connected by several high-speed train lines.

So what makes Yokohama stand out? Its main port, the Minato Mirai, which, although it was one of the first Japanese ports to open to foreign trade in 1859, gives a futuristic touch to the city.

It is famous for its vast Chinatown, where restaurants and stores are counted by the hundreds, and for its Sankeien Garden, which houses extremely well-preserved ancestral Japanese residences.

Last but not least, there is a ramen museum where you can create your own broth before enjoying it.

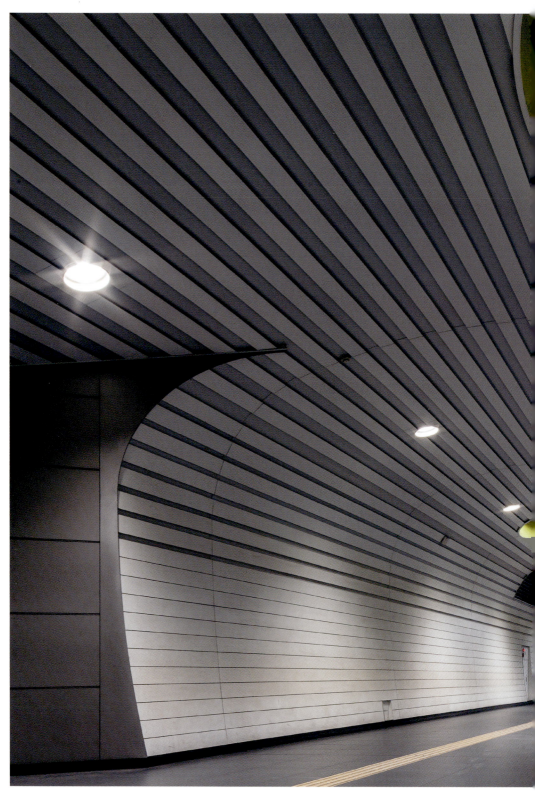

The alleys of the Yokohama subway

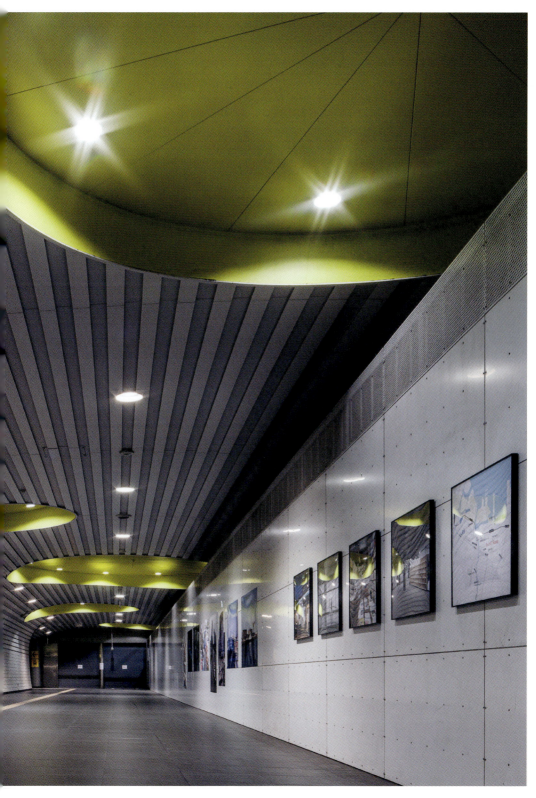

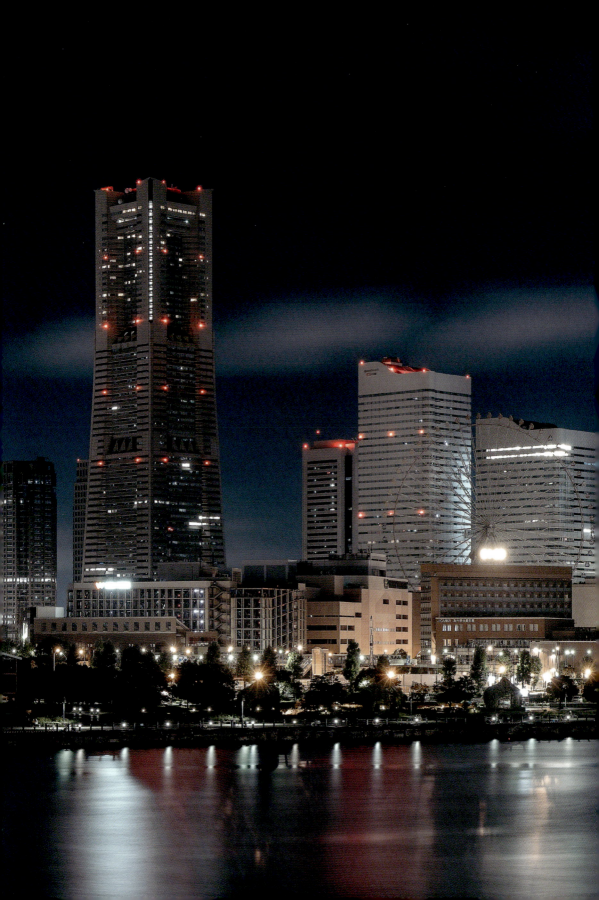

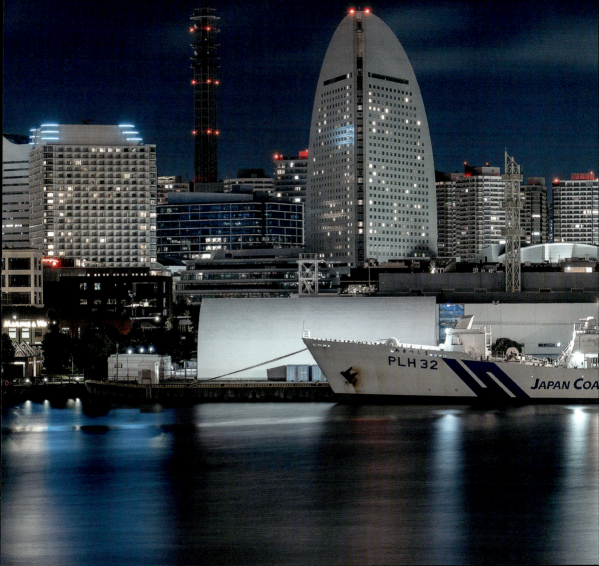

(Kōbe)

Kobe

Clinging to a hill overlooking the sea, Kobe is not only one of the most beautiful cities in Japan, but also certainly one of the most cosmopolitan of the island.

Its port was authorised to practice international trade since the end of the 19th century and, at that time, already welcomed the first foreign communities, present since the reopening of the country to the world.

Kobe quickly became the main gateway for maritime trade with China and the symbol of economic dynamism, which led to it being bombed at the end of the Second World War. However, the port of Kobe still prospers today with, more specifically, the extension of the industrial park on the sea.

Although the city was not spared by history – no one has forgotten the terrible earthquake of 1995 – it has rebuilt itself intelligently by developing thoughtful urbanism while preserving the vestiges of its tormented past.

Today, Kobe is still very popular with expatriates for its gentle way of life and its lively nightlife, and welcomes many Westerners in its European neighbourhoods filled with Norman, Belgian, or English-style houses. It has many assets: its relatively modest size which makes it a city where it is good to stroll, but also its attractive districts of Kitano-chō, Nankinmachi, and Chinatown. After dark, the lively area near Sannomiya Station is a favourite, as most of the sites are within walking distance.

The famous Kobe beef

How can we talk about Kobe without mentioning its famous beef? This delicacy is a registered agricultural trademark that refers to a particular variety of beef from the Tajima cattle breed. This breed is raised according to the strictest tradition in the prefecture of Hyōgo, of which Kobe is the main city. It is even said that the animals are raised to the sound of classical music and are massaged every day.

The local beef (which is not necessarily overpriced) is inextricably linked to Kobe and is a 'must eat' no matter where you are in Japan. Its meat, as marbled and tender as can be, leaves a delicious memory to all those who have tasted it.

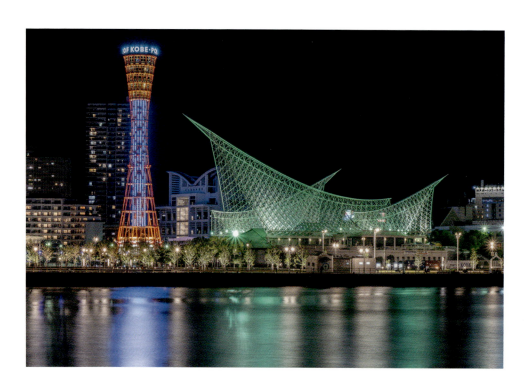
The Kobe Port Tower and its hyperboloid structure offering a panoramic view of the city from a height of 108 meters (sacred number in Buddhism)

Kobe

Life-size replica of the hero Gigantor
in Wakamatsu Park

Akashi Kaikyō, the longest suspension bridge in the world ▶
connecting Kobe City in Hyogo Prefecture to Awaji Island

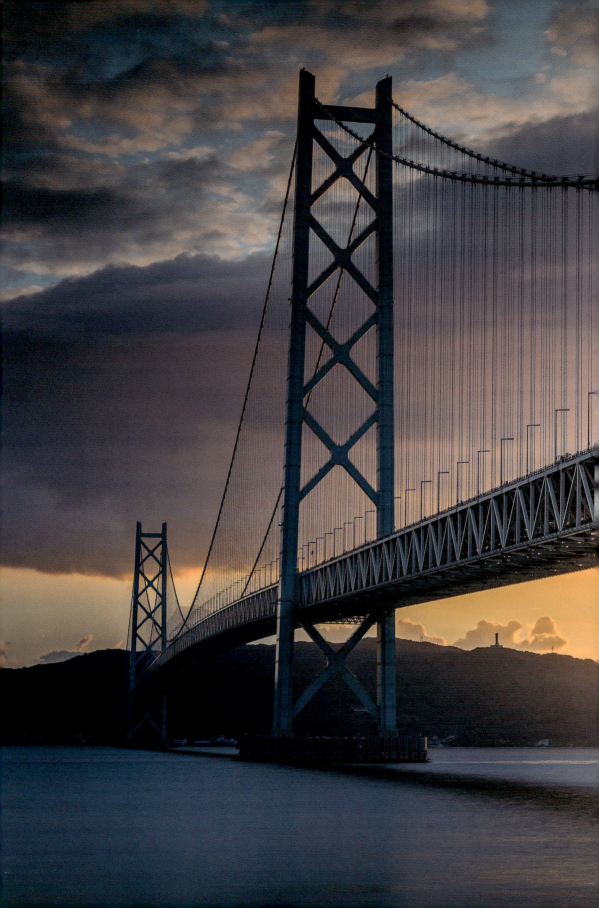

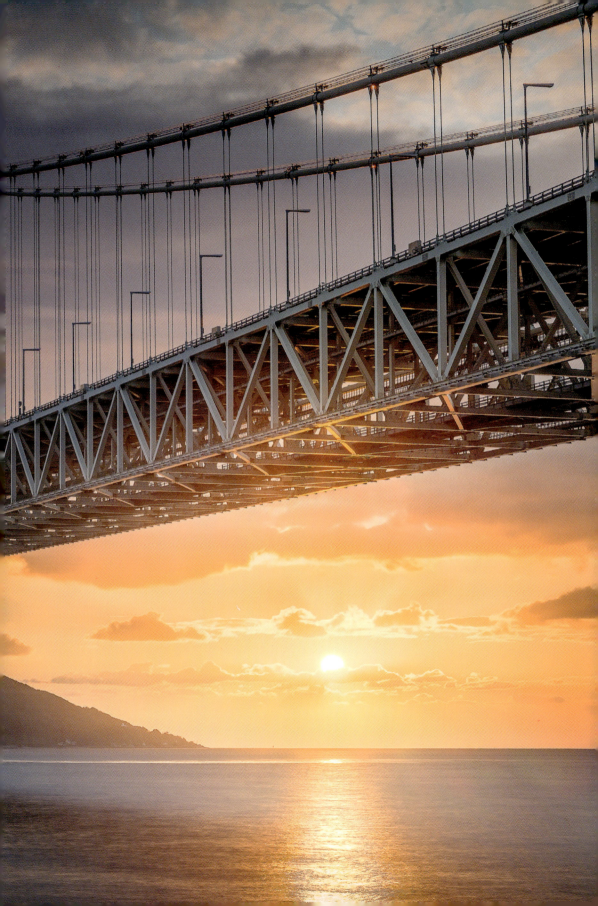

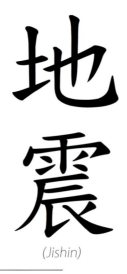
(Jishin)

Earthquakes

It is a well-known fact that, in Japan, the risk of earthquakes is particularly high because of the tectonic movements that occur near the island, under the ocean. It is therefore not impossible that you will be facing one or more earthquakes during your stay in the archipelago.

More frequent but also much more monitored than anywhere else in the world, the 100,000 or so Japanese earthquakes recorded each year represent 10% of the earthquakes recorded in the world.

But rest assured, the vast majority of these seismic phenomena are barely perceptible and their effects are almost minimal. Each year, only 1,000 to 1,500 tremors have a magnitude higher than 1 on the Richter scale and can therefore be felt by human beings. Similarly, while humans are only really aware of earthquakes when their magnitude exceeds 3, it should be noted that Japan has only recorded, on average and since the beginning of the 20th century, one earthquake per year with a magnitude greater than or equal to 7 on the Richter scale.

Strict rules

Given the risks that the most important tremors can represent, Japan imposes strict rules, especially in the construction sector.

For example, as you walk around the cities, you will notice that the single-family houses never have basements and that the whole house is 'laid' on steel frames, themselves mounted on powerful cylinders. Furthermore, no single-family home is terraced since a space between each dwelling is always respected to prevent a possible domino effect.

Another striking detail: Tokyo's buildings, whether small or huge, have an extremely limited life expectancy. Twenty-five years on average, not more! This is due to the numerous earthquakes that quickly wear out the materials used. This explains why most Tokyoites don't feel the urge to buy properties.

Reassuring buildings

Whether it is because of natural disasters, the anti-seismic technological evolution that they impose, or the transformations brought in by the Olympic Games, it is clear that the urban scenery of Tokyo and the main cities of the country are evolving at a rapid pace.

What does not change, however, and what may surprise more than one Westerner, is how the electrical and telephone cables are visible everywhere. Indeed, due to the tectonic movements, the cables are not buried in the ground as we are used to, but instead are entangled in the air, on poles for example.

What about high-rise buildings? In Japan, towers are built in such a way that they 'absorb' earthquakes of a high level on the Richter scale (8, 9). For many, these buildings – whose construction has been perfectly thought through – are so reassuring that they might be the best place to take shelter in case of an earthquake.

Although Japanese people have been confronted with earthquakes from a very young age, specific training is given to children in schools and regularly reminded in companies, and even in subway stations.

Finally, for the most worried, you should look for the numerous shelters or refuges in the administrations, schools, or gymnasiums. There, everything is provided to take shelter in case of serious earthquakes.

And if this is not enough to reassure you, you can visit the museum in Ikebukuro, Life Safety Learning Center, where you can feel, by simulation, earthquakes of various magnitudes.

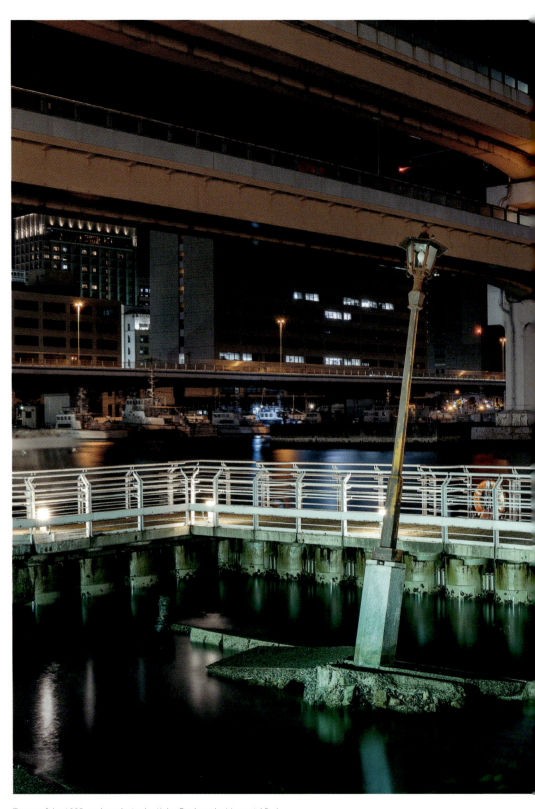
Traces of the 1995 earthquake in the Kobe Earthquake Memorial Park

Earthquakes

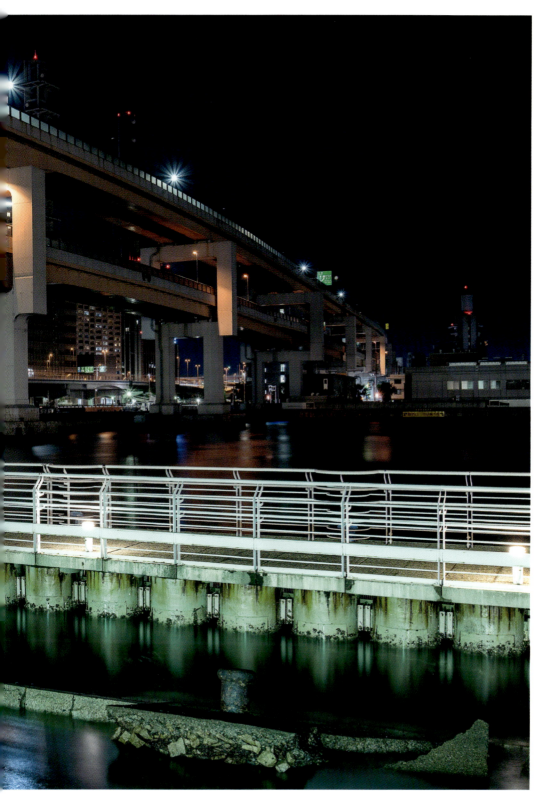

高野山

(Kōya-san)

Kōyasan

Southeast of Osaka, Kōyasan is a mountain range that gives its name, among other things, to a group of Buddhist temples.

The jewel of the Honshū peninsula, and more precisely of the Wakayama Prefecture, it is renowned for being the site of the largest waterfall in Japan, the 133m high Nachi Falls. Mount Kōya itself culminates at nearly 1,000m above sea level and has been a sacred place for 1,200 years.

Kōbō Daishi, who brought Buddhism to Japan, made Kōyasan a holy site, with the support of the then emperor in the 9th century. Since then, the peak and its heavenly cemetery are very regularly depicted in Japanese prints. The Dalai Lama, Buddhism's highest spiritual authority, visited Kōyasan in person, allowing him to observe the Garan (or sacred precinct) and its temples and pagodas, as well as the Okuno-in and its vast cemeteries consisting of 200,000 graves. This sacred place, far from being sinister, is where every Japanese Buddhist wishes to have his tombstone.

How do you reach that place?

Of all the ways to reach the top of the mountain, the most original is certainly the small rack train that climbs the steep slopes. This mountainous landscape used to isolate the Buddhist monks from the rest of the world. But the place is now more accessible and always welcoming, with the monks ready to share their rituals as well as the food and lodging with their visitors of the day. The only condition is that you must arrive very early in the morning or agree to spend the night in the mountains, as is done in our abbeys.

Note that several packages exist and allow you to visit the whole site and its temples.

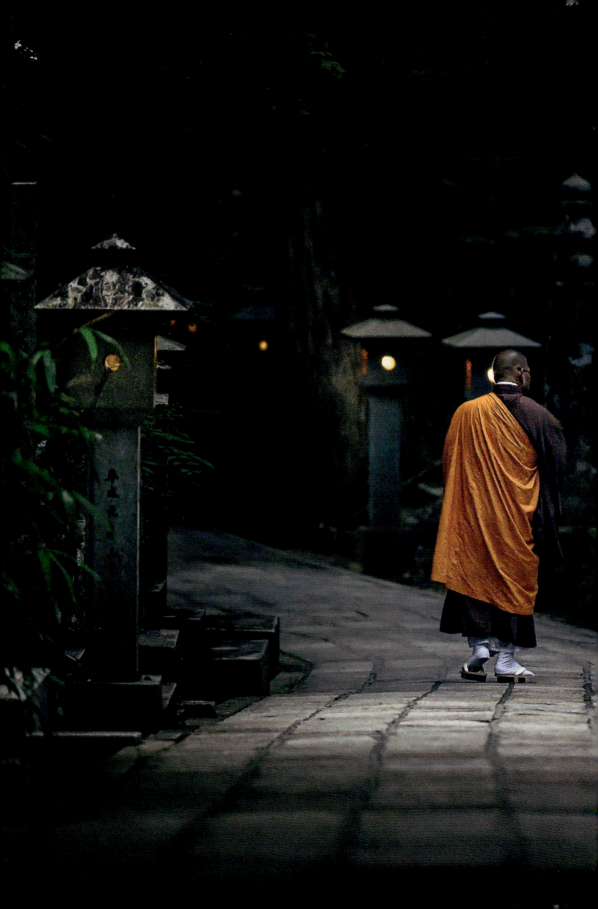

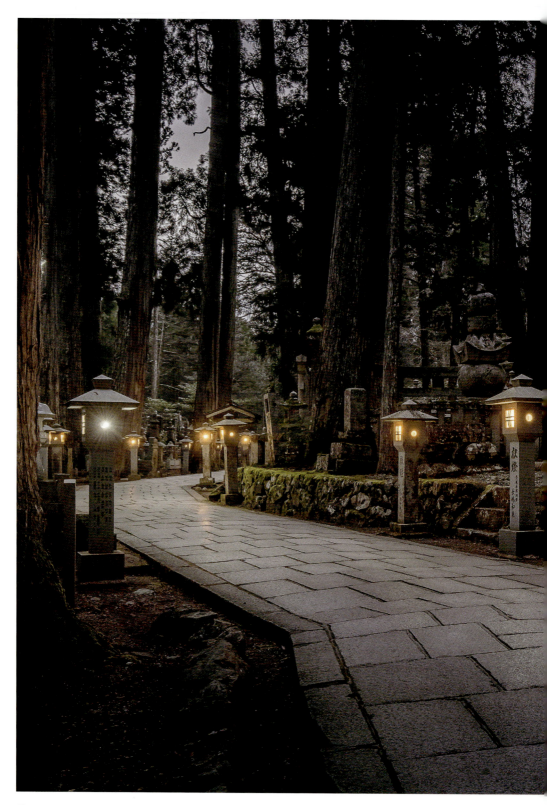

Okuno-in, Mount Kōya's cemetery

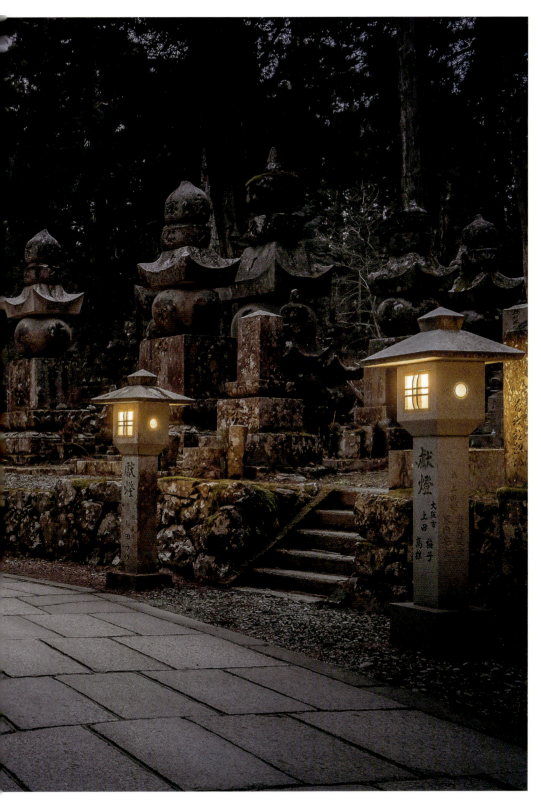

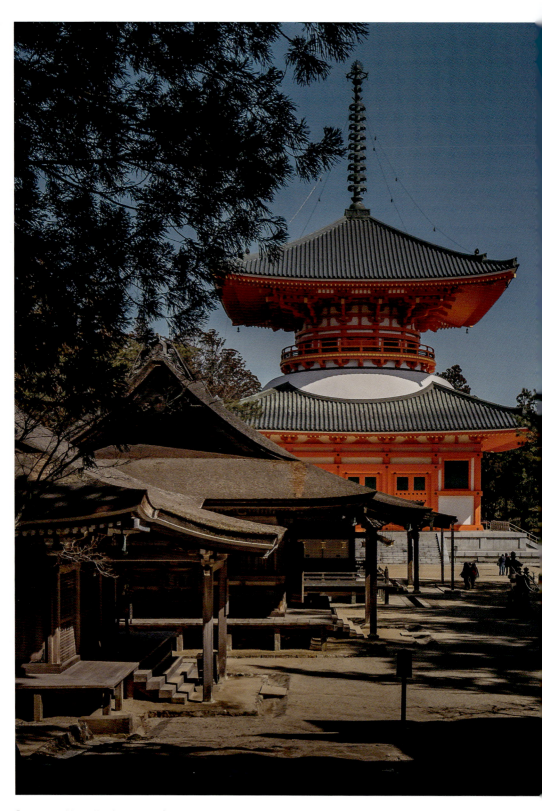
Danjōgaran, Mount Kōya's main temple

Kōyasan

(Matsumoto)

Matsumoto

A pleasant and airy city in the heart of what is known as the Japanese Alps, Matsumoto has kept alive many remnants of its past, particularly its 16th-century castle, whose foundations date back to the 8th century. Characteristic of the Sengoku era, this architectural jewel is nicknamed 'the Black Raven' for its colour.

Matsumoto-jō, in addition to offering a superb view from its main tower, is also the oldest wooden castle in Japan. This makes this national heritage site a must-see place in a country where castles are extremely rare – mainly because of the will of 19th-century emperors to put an end to the feudal power of samurais. Indeed, under the Tokugawa shogunate (dynasty), which ruled Japan from 1603 to 1867 – a reign better known as the Edo period – it was forbidden for a samurai to own more than one castle, even if it meant that his other buildings had to be demolished.

However, Matsumoto is more than a castle... A historical rival of its neighbour Nagano, where the Winter Olympics were held in 1998, the place is also worth a visit for its scenery and its natural resources. Here, the surrounding peaks – some of which exceed 3,000m – are part of a protected national park, whose landscapes are among the most beautiful in Japan. This volcanic region is also appreciated for its numerous hot springs and ski resorts.

Matsumoto

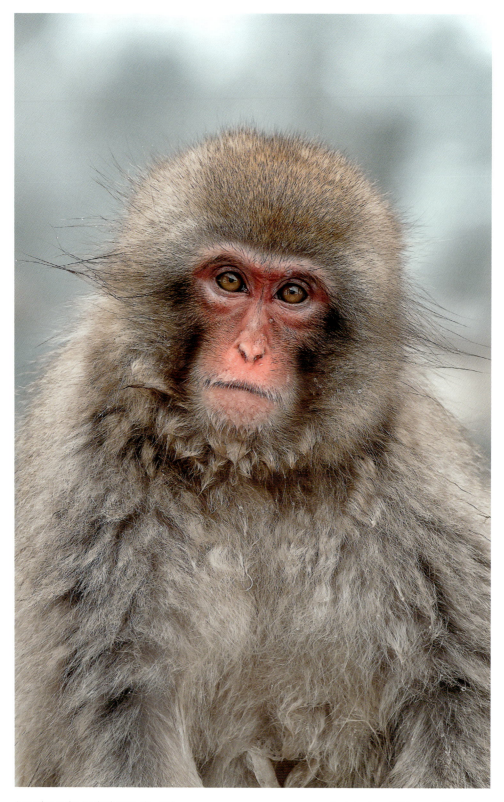

A monkey in the Jigokudani Monkey Park

A winter view of Matsumoto Castle ▶

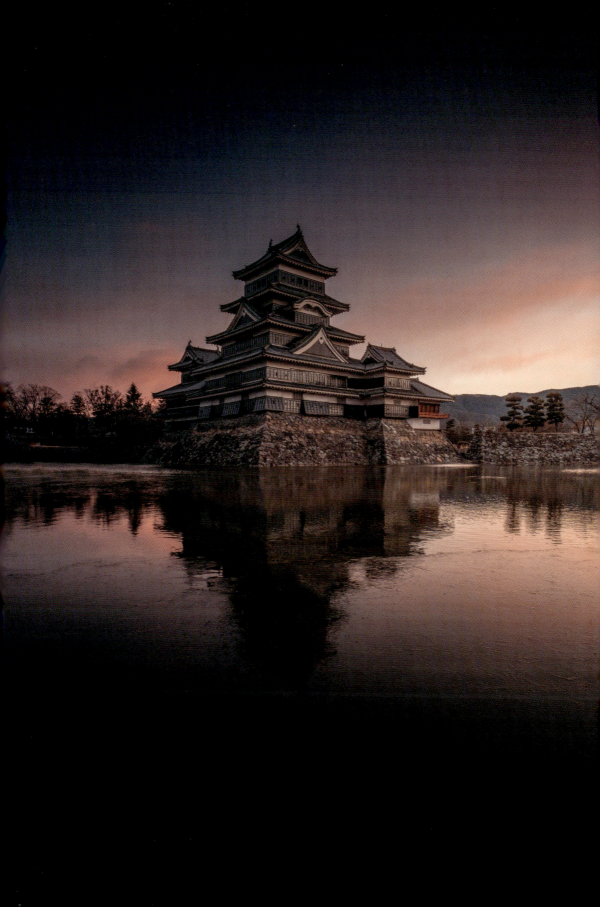

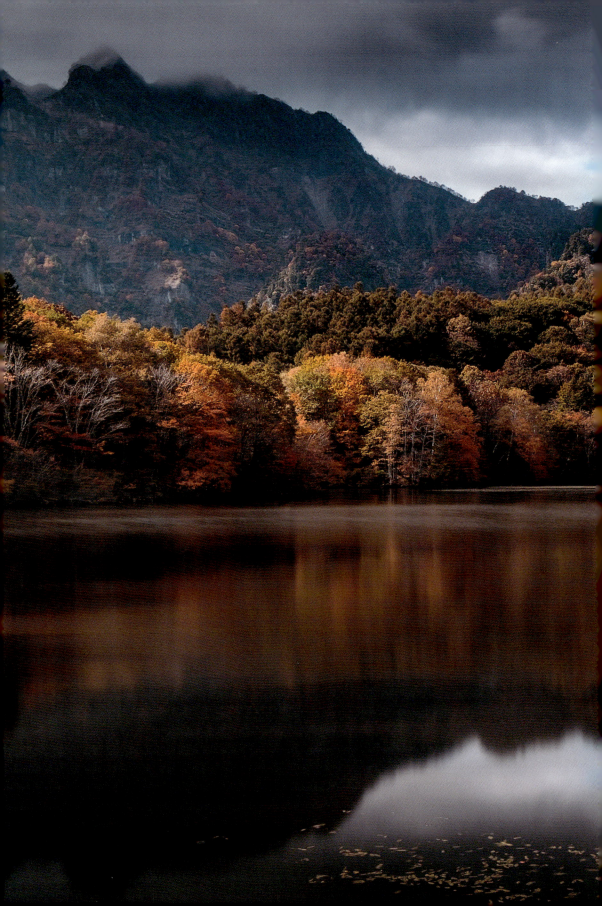

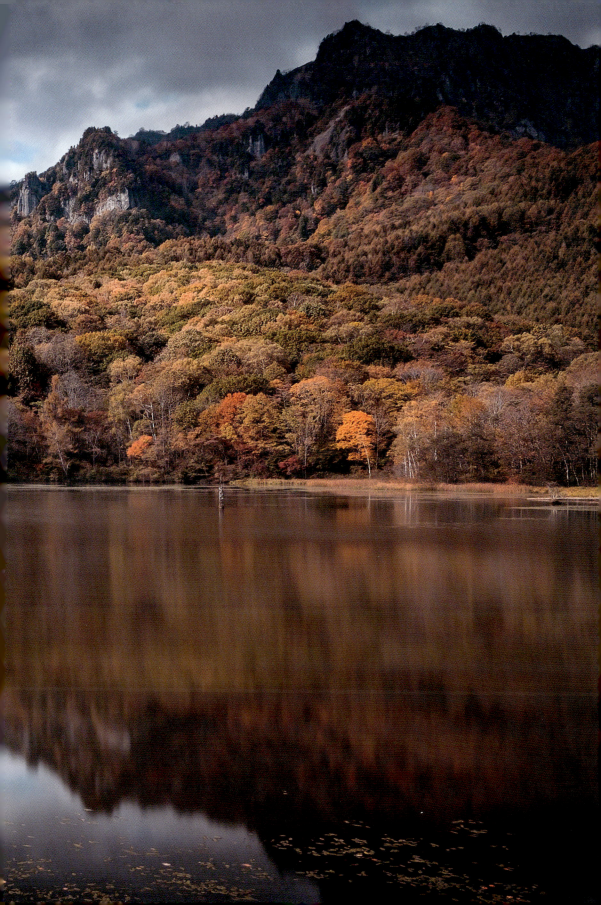

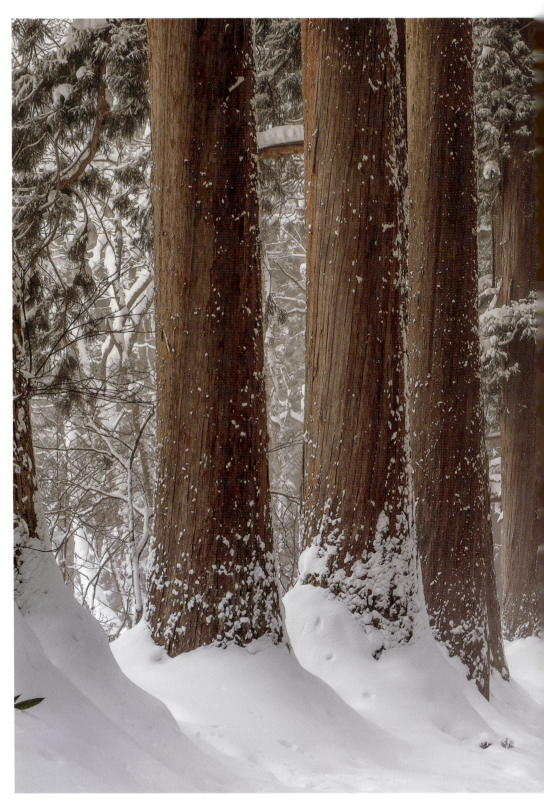

◀ Lake Kagami-ike, near Nagano

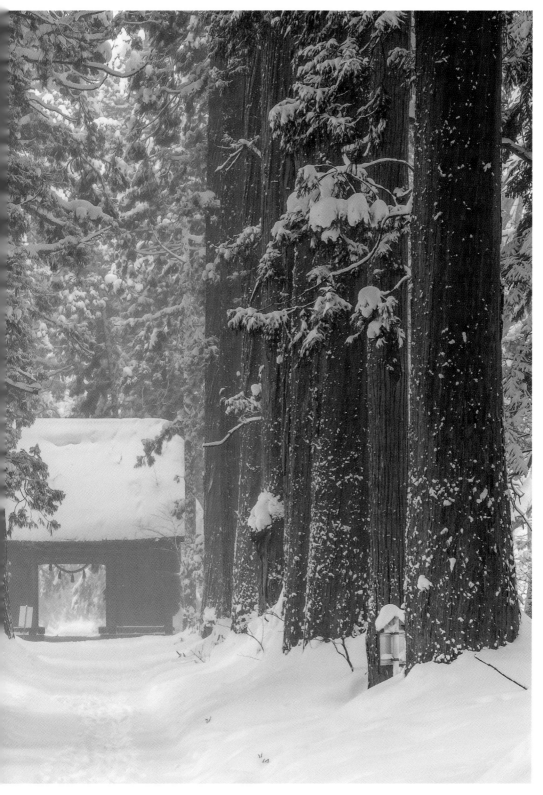

The cedar forest leading to Togakushi Shrine under the snow

九州

(Kyūshū)

Kyūshū

Japan's third-largest island, Kyūshū is also the southernmost of the archipelago. Its name refers to the provinces (Kyu-shu, 'nine provinces') that made it up in medieval times, before the Meiji era.

Here, it is impossible not to fall under the spell of its numerous volcanoes and their hot springs, which offer fantastic panoramas of lush green nature.

In addition to its scenery, Kyūshū, now divided into seven prefectures, is also known for its rich culture, pottery and subtropical climate – it is the sunniest island in Japan – conducive to citrus, bamboo, and palm tree plantations.

Kyūshū holds a special place in the hearts of the Japanese. And for good reason, as many of them see in this island the cradle of their civilisation. A land of legends and myths where the founding gods of the country and the imperial dynasty appeared. A welcoming land where most of the Japanese ancestors from China and Korea transited. A land of abundance where rice, Buddhism, and writing, so dear to the Nipponese, were able to find fertile grounds before invading the rest of the archipelago, and thus give its identity to an entire nation.

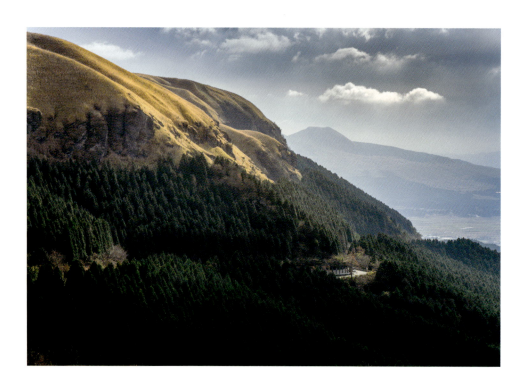

By Mount Aso, the volcano in the center of the island

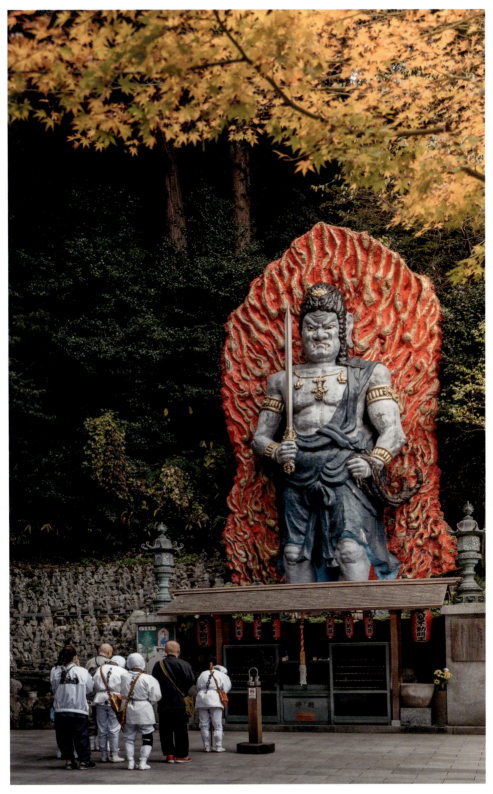

Pilgrims at Nanzoin Temple, in Fukuoka, North of Kyūshū

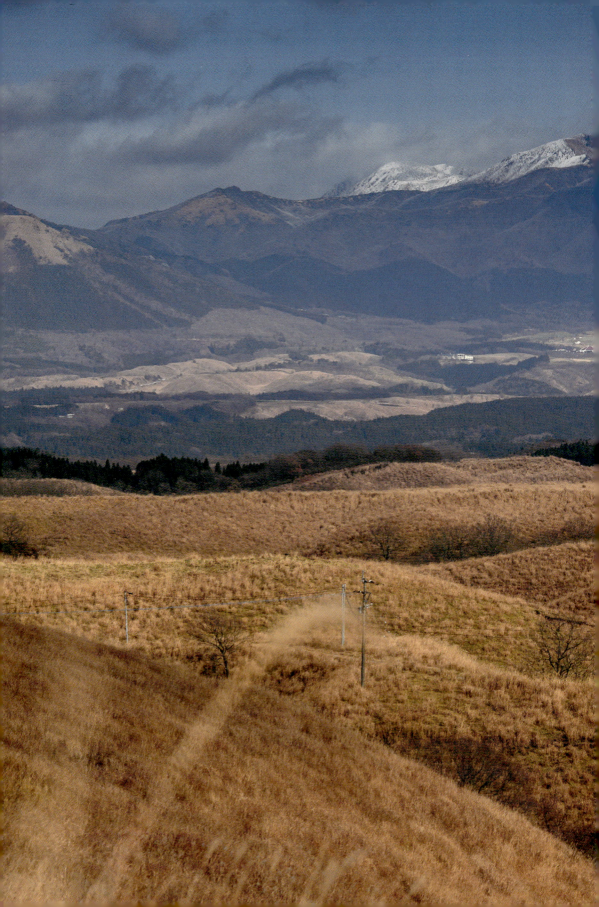

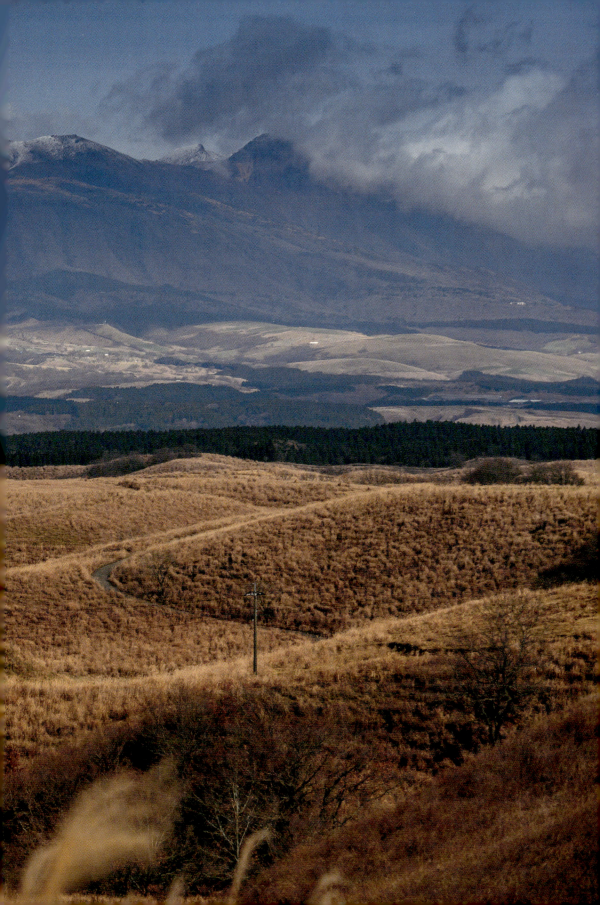

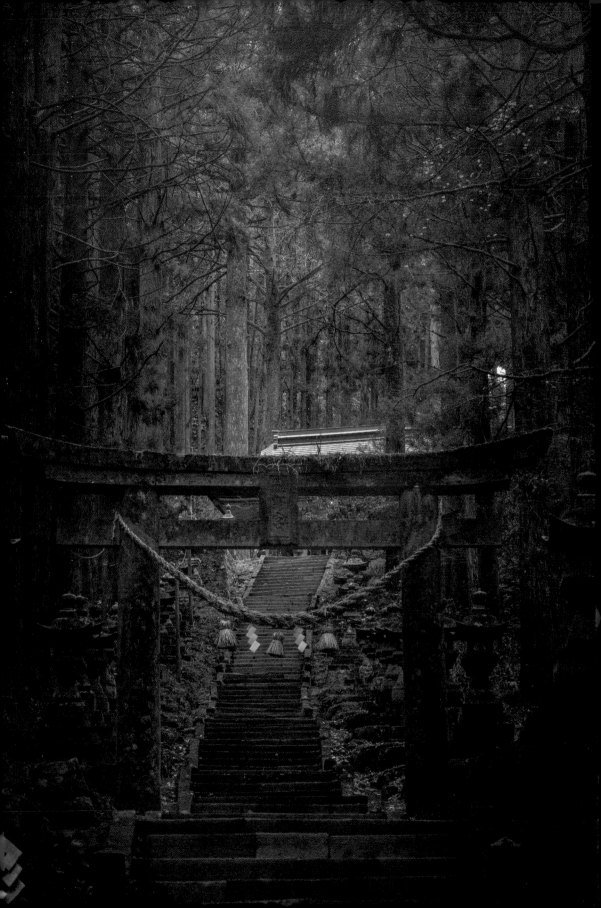

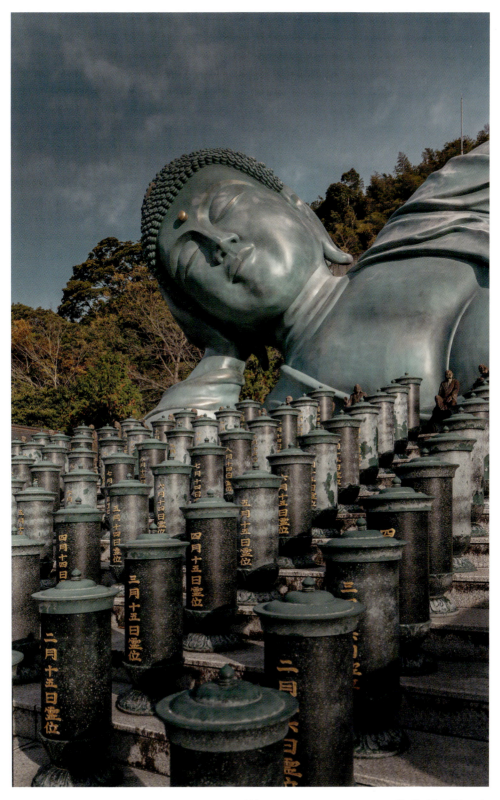

◀ The sanctuary of Kamishikimi Kumanoimasu in Takamori

The Buddha of Nanzoin

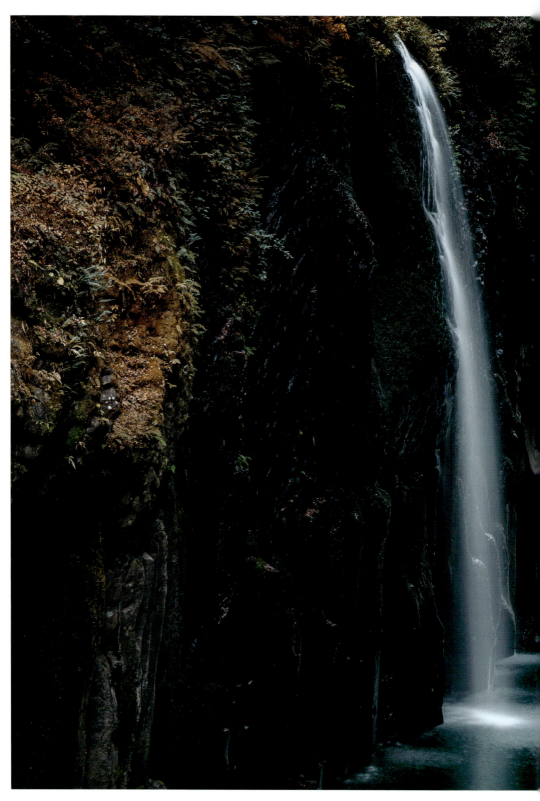

Takachiho Gorge,
natural and mythological site of the Kyūshū region

Kyūshū

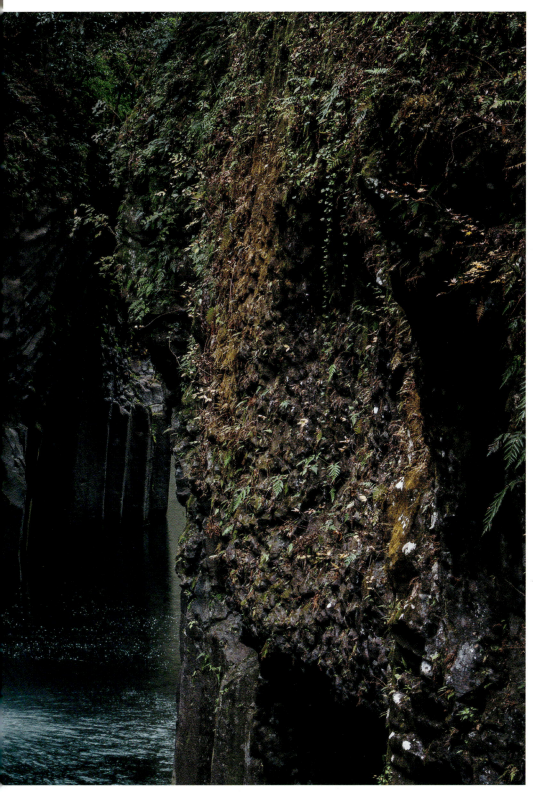

北海道

(Hokkaïdo)

Hokkaidō

In a country where millions of city dwellers live in the constant oppression of huge crowds, crowded subways, and cramped apartments, Hokkaidō, located nearly 1,200km from Tokyo, stands out with its wide, open spaces and preserved environment.

Home to beautiful national parks such as the Akan Park and the incredible Shiretoko Peninsula – one of the few remaining areas of wilderness in Japan – the island constantly amazes with its mountains, old-growth forests, volcanoes, and tropical blue caldera lakes. Here, Mother Nature is queen!

Considered by many Japanese as the country's last frontier with the Far North – admittedly, the region is remote from everything and entered the modern era late – Hokkaidō surprises by its authenticity, far from the usual clichés about Japan.

Visiting the island is like setting foot on a land of fire and ice. A corner of paradise where the summer weather, often mild, delights hikers and cyclists, while in winter, the thick layers of snow attract thousands of skiers in search of flawless powder snow (as in Niseko) in what has become, over the years, the leading winter sports destination in Asia.

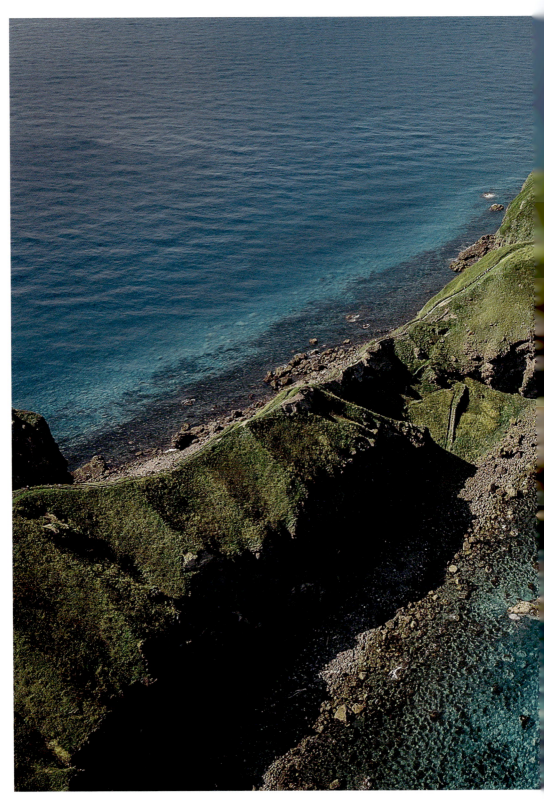
Aerial view on Cape Kamui

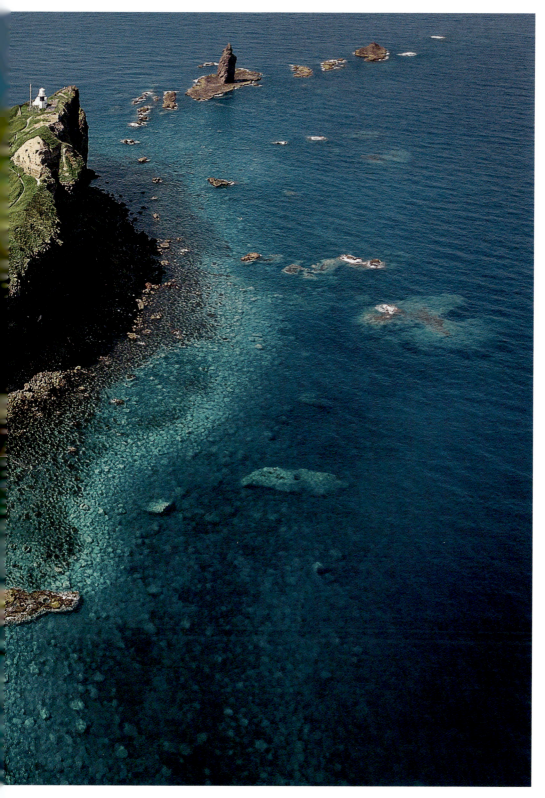

The Hill of the Buddha by famous architect Tadao Andō

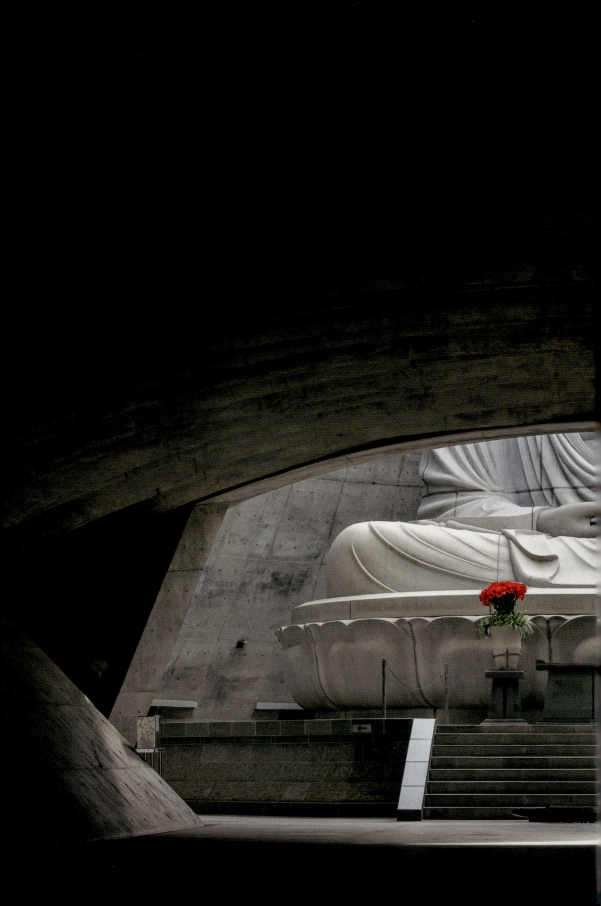

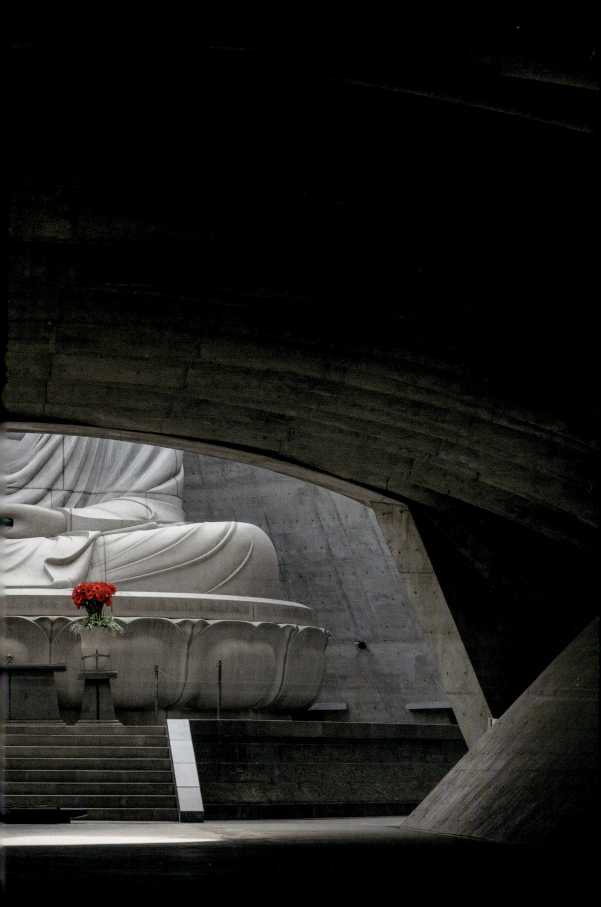

Hokkaidō

Shiretoko National Park and its wildlife Cape Sōya, the northern point of the archipelago

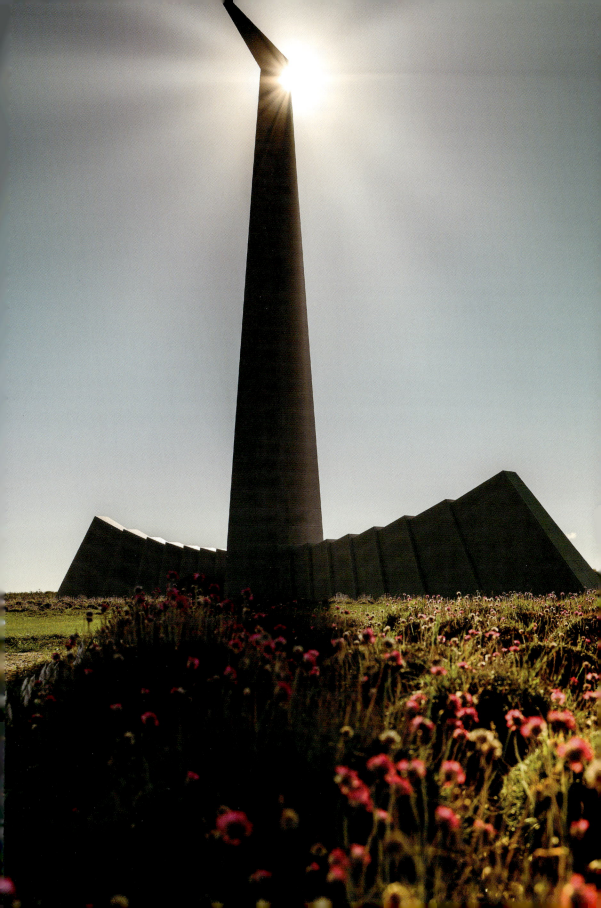

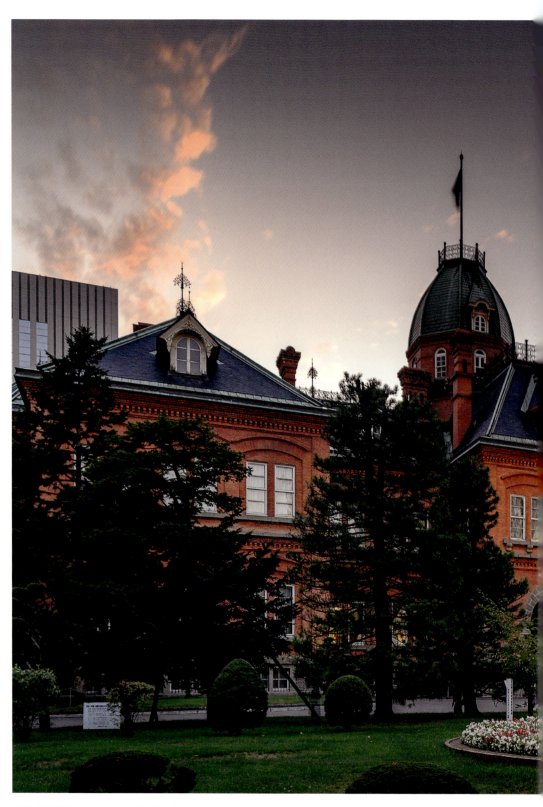

Hokkaidō's historic government building in Sapporo

Hokkaidō

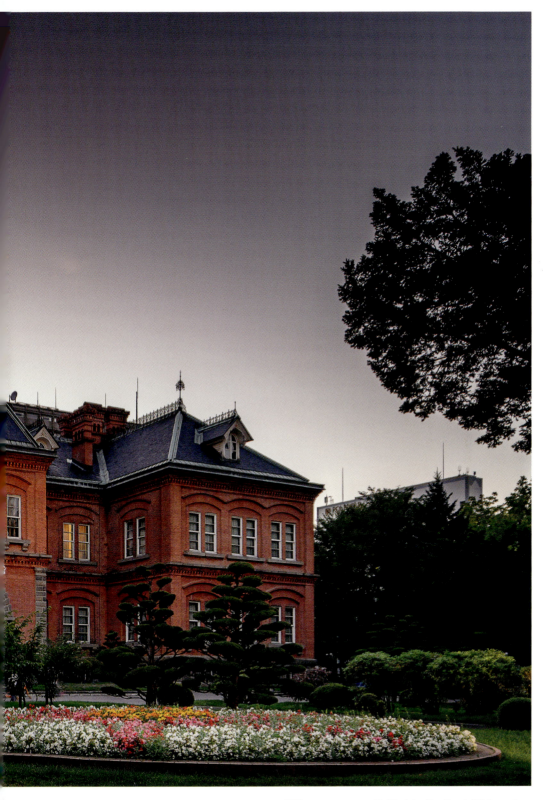

'Aoi-ike', the Blue Pond of Biei area ▶

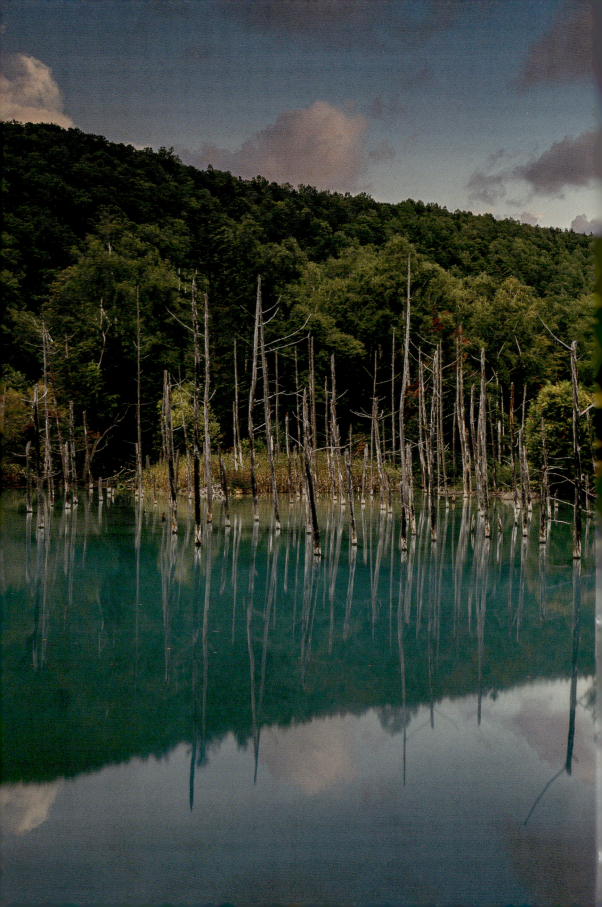

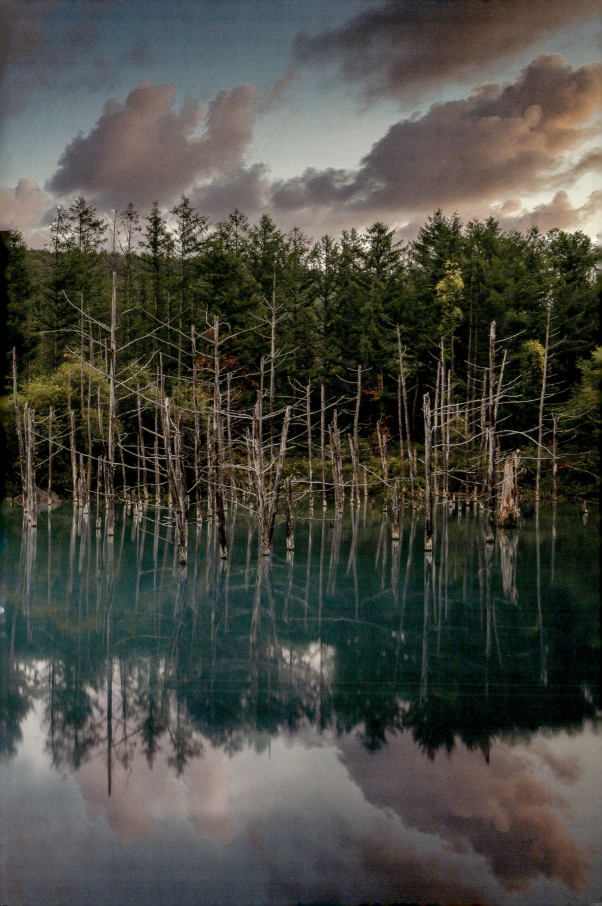

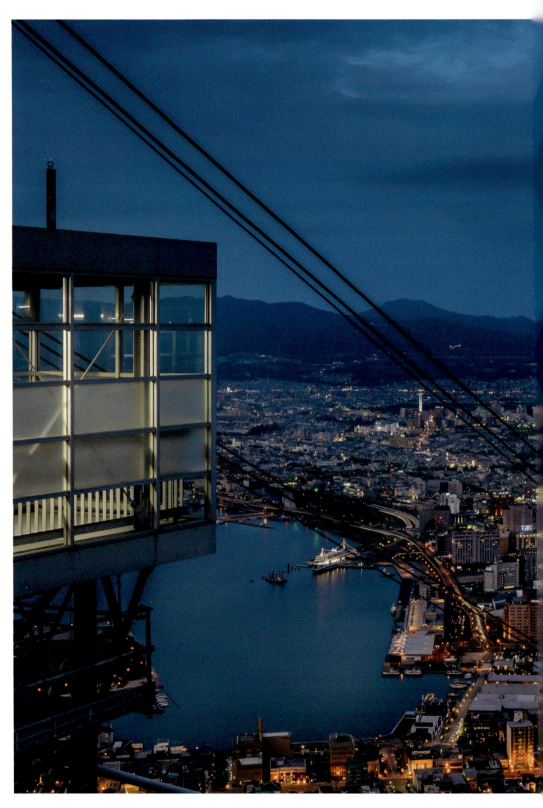
Panorama from the observatory on top of Mount Hakodate

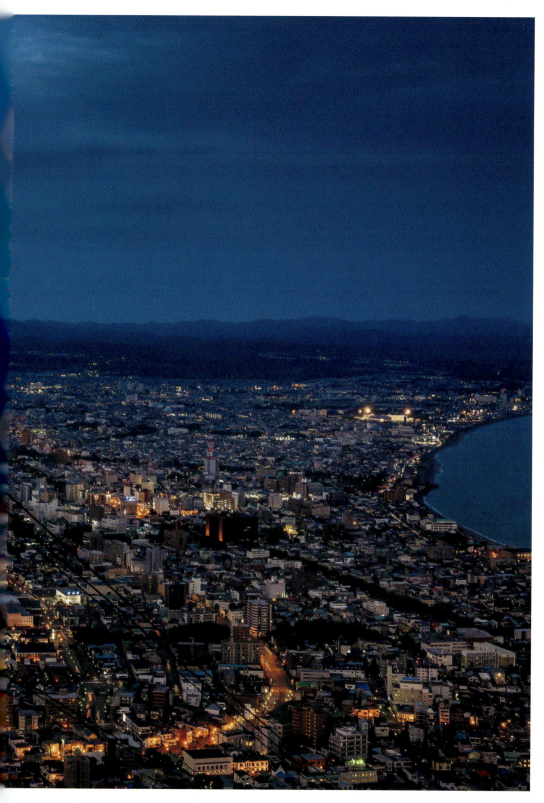

Acknowledgments

As is often the case when starting a new project, you have to face many obstacles. Fortunately, some people are always there to support you, encourage you, and push you to excel. I would never have dared to imagine publishing my photos in a book without the encouragement and support of certain people.

I would like to sincerely thank my family and friends who have been with me since the beginning of this adventure, in 2013. Among the first to believe in me, at a time when my photos could have made real photography professionals laugh, they all found the right words to advise and motivate me over the years.

Now more than ever, the secret to success is to keep learning forever. My family has always believed in me, and I would like to thank my mother who was certainly my first fan. Her unwavering support constantly pushes me to give my best, even though I know she is (obviously) not always very critical of my work – she marvels at all my shots, including those of my dogs...

I would also like to thank Connections as well as the brands, *F-stop and Samyang*, that I have the honor to represent in Japan.

And last but not least, I salute my wife who, thanks to her Japanese mentality of patience and perseverance, has always looked at my work with a critical eye.

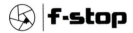 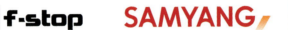 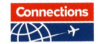

Photographs: ©Nicolas Wauters
Texts: Nicolas Wauters
Translation: Alizée Ortegate
Review: Lea Teuscher
Layout: Xavier Maurissen, Véronique Lux

This book is published by Éditions Racine.
Éditions Racine is part of the Lannoo Publishing Group.

www.racine.be
www.lannoo.com
Register for our newsletter to receive information regularly on our publications and activities.

All rights reserved. No part of this publication may be reproduced, stored in a retrieval system, or transmitted in any form or by any means, electronic, mechanical, photocopying, recording or otherwise, without the prior permission of the copyright owner.

© Uitgeverij Lannoo nv, Tielt, 2022
D. 2022. 6852. 9
Legal deposit: April 2022
ISBN 978-2-39025-169-9